TUBE
LIFE

TUBE LIFE

LONDON'S UNDERGROUND IN PHOTOGRAPHS

mirrorpix

The History Press

First published 2018

The History Press
The Mill, Brimscombe Port
Stroud, Gloucestershire, GL5 2QG
www.thehistorypress.co.uk

British Library Cataloguing in Publication Data.
A catalogue record for this book is available from the British Library.

ISBN 978 0 7509 8597 0

Typesetting and origination by The History Press
Printed in Turkey by Imak

INTRODUCTION

The London Underground has always been key to the lives of Londoners; from when its stations and stairwells offered refuge from the barrage of the Blitz to its ability to transport 4.8 million people every day. Much like the people it transports, it is resilient to threat and horror, standing strong in the face of war, terrorism and tragic accidents.

The Underground was the world's first underground railway, opening in 1863 as the Metropolitan Railway, and is now the eleventh busiest metro/subway in the world. It is an art and design icon, with instantly recognisable fonts and branding – and an unmistakeable map!

But the Tube has never sat on its laurels, instead constantly building and reshaping to fit London. New lines and stations are always being built, new trains commissioned, and better accessibility is being strived for. It is home to the largest infrastructure project in Europe: the Elizabeth line, due to open in December 2018. The second line to be named after Elizabeth II, this will stretch right across central London, linking Reading and Heathrow to Shenfield and Abbeywood. It will be another vital artery feeding into the beating heart of the capital.

Tube Life is a celebration of those arteries, but also the people that keep the Underground alive – through shelters and bombings, derailments and disasters, to escapades and adventures. Mirrorpix, a formidable photo archive of contemporary images, has opened its doors to reveal the day-to-day life of a worldwide icon.

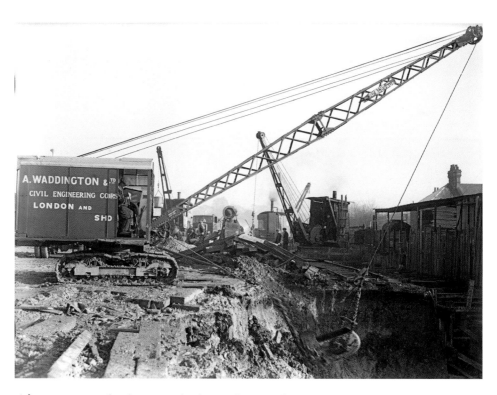

▲▶ Excavations for the new Uxbridge Underground Station in 1936.

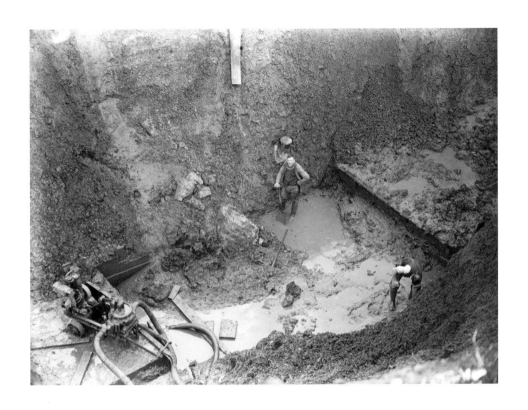

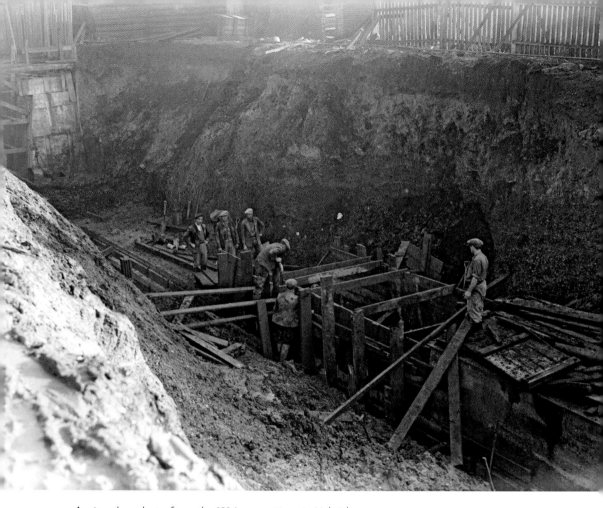

▲ Another photo from the 1936 excavations in Uxbridge.

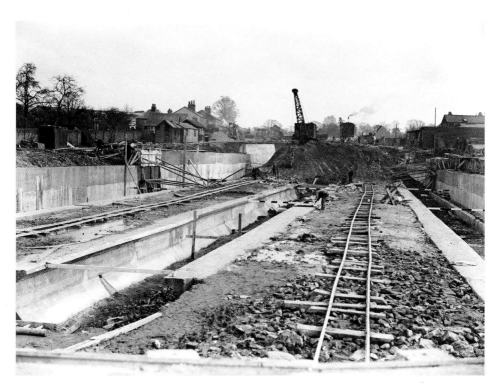

▲ Platforms under construction at the Underground station, Uxbridge, 1936.

THE BLITZ

When the Luftwaffe took to the air, Londoners took to the ground. There were no large communal air raid shelters in London, so the Tube stations took this role. Originally the government banned using Tube stations as shelters, but were forced to change their mind when faced with hordes of scared citizens waiting outside the stations each night.

While only 4 per cent of Londoners used the Tube for shelter, it's thought that this percentage was made up of those living and working in the centre or the docks – the most vulnerable. The Tube was there for those who needed it most.

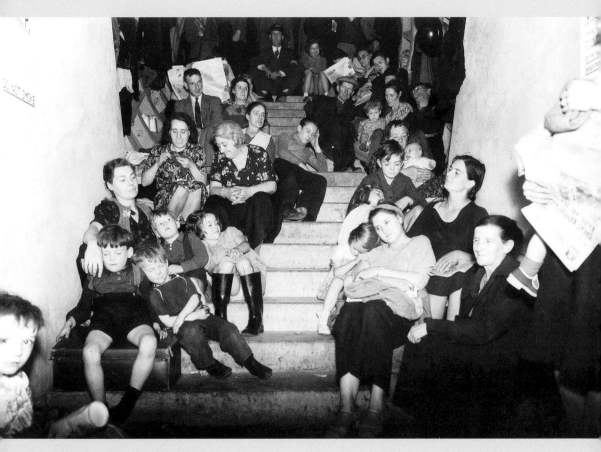

▲ **September 1940.** Families take cover from the Luftwaffe bombing of London in this disused Underground tunnel.

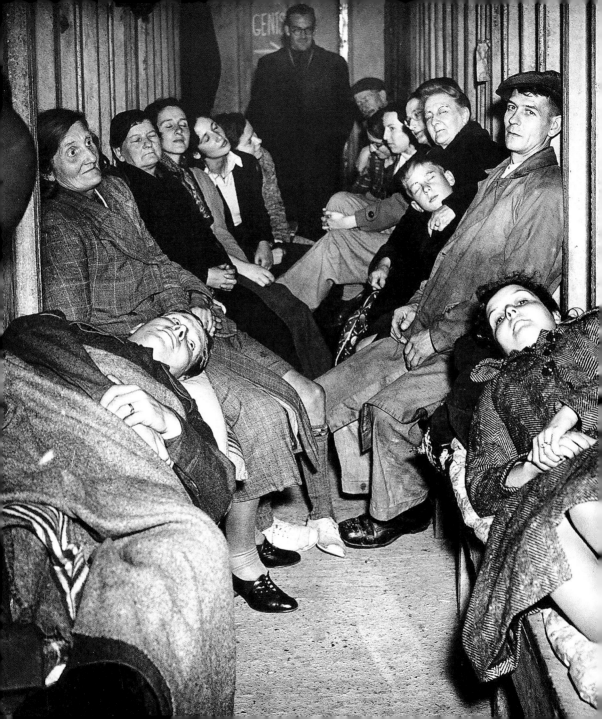

◀ **30 September 1940.** Lance-Corporal Herbert K. Knightley (front left) and his bride, Miss Irene Bavin (front right) in their bridal chamber. They settled down to sleep after relatives had drunk to their health. The *Mirror* reported:

Bombed out of her home twice in a fortnight, a twenty-year-old bride spent the first night of her wedding with her soldier husband in an underground air raid shelter in Heston (Middlesex). The parents of both the bride and the bridegroom sat at their side. The girl was Irene Bavin, of Southwell-road, Camberwell. A few hours after the wedding she and her bridesmaids took off their silk dresses, put on day frocks, and went to the shelter. The young husband, Lance-Corporal Herbert Kitchener Knightley, twenty-four, of West Way, Heston, blushed when the 200 men, women and children in the shelter called out good wishes as the bridal party walked down the steps. Then, while A.A. guns boomed outside, relatives drank their health as they sat on benches along the walls.

'It is not a bit like I imagined my wedding night would be a few weeks ago,' the bride told me before she and her husband settled down for the night, with travelling rugs around their shoulders. 'We're lucky, but I suppose we were lucky to have a wedding at all. My family and I were bombed out of our home at Brixton. Then we moved to a relation nearby, and were bombed out of their home, too. So we came to live with Herbert's mother.' She turned to her husband. 'But we are happy dear, aren't we?'

'Yes,' replied Lance-Corporal Knightley, 'And still keeping our chins up.' The bride did not know until the previous day whether the young soldier would be able to get leave for the wedding, although the date had been fixed and the banns read. 'I'm not particular on going to the shelter,' Lance-Corporal Knightley said. 'But it is better for Irene.'

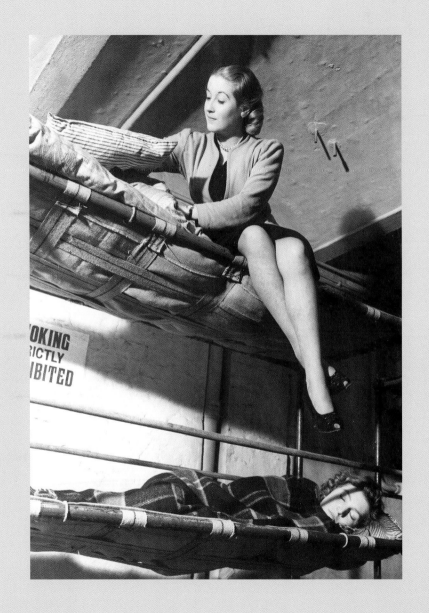

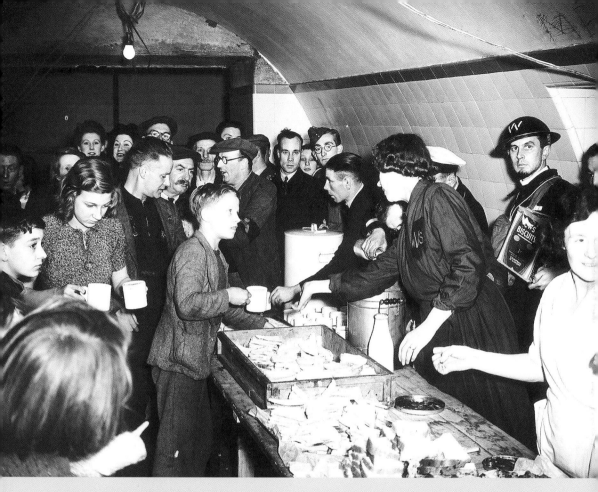

▲ **13 October 1940.** The Women's Voluntary Service serve tea and sandwiches to people in the Liverpool Street Underground air raid shelter.

◀ **November 1940.** A woman fixes her mattress and pillows on the top bunk of her bed as she prepares for a night's sleep in an air raid shelter.

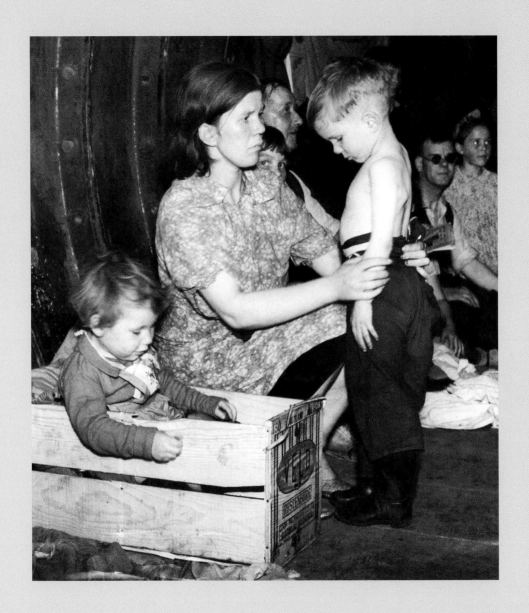

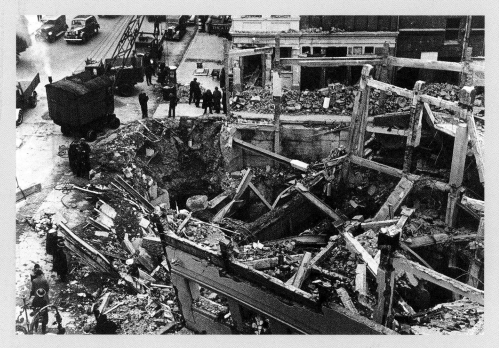

▲ **12 November 1940.** Workmen and rescue services work on the bombed remains of Sloane Square Underground Station.

◀ **21 September 1940.** A mother tends to her young son while her daughter settles into a bed made from a wooden fruit box. It's estimated that 177,000 people were using the London Underground for shelter by the end of September 1940.

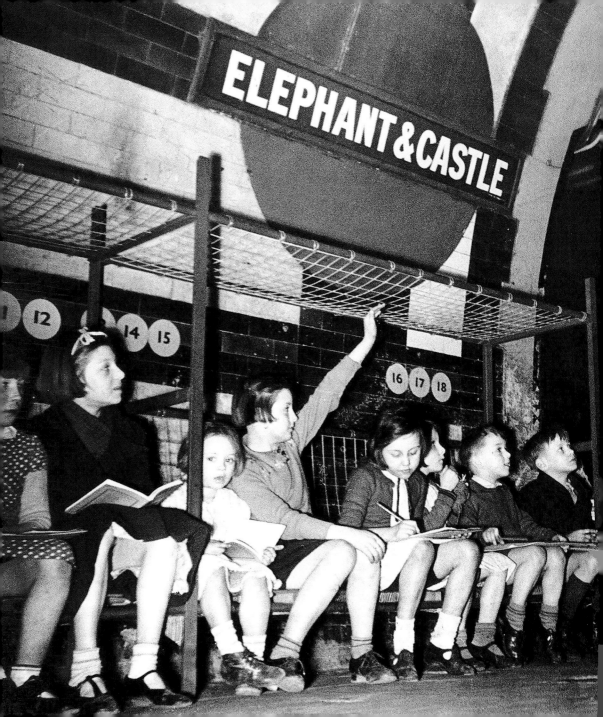

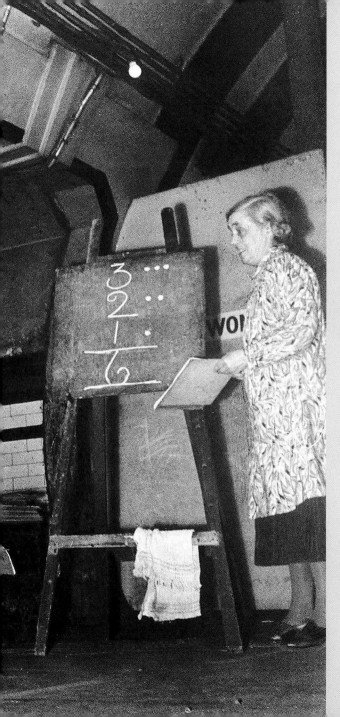

◀ **March 1941.** Miss A. Potter teaches children in a maths lesson in the Elephant & Castle Underground Station.

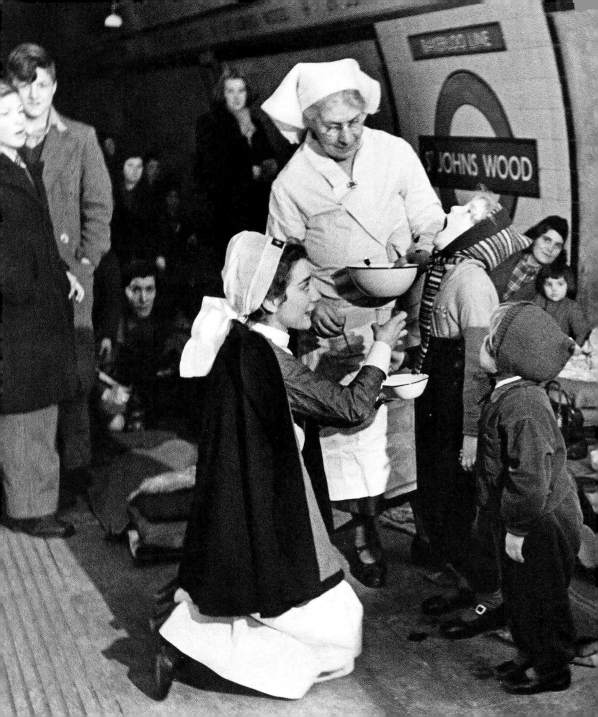

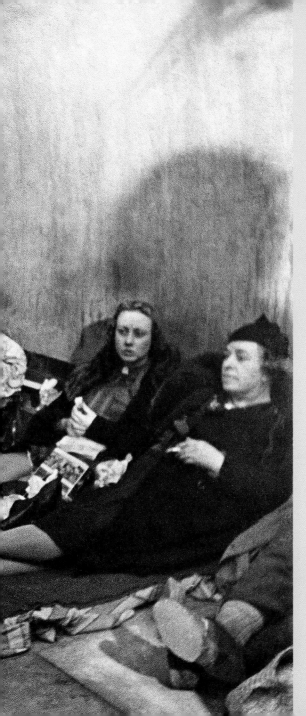

◀ **January 1941.** Nurses give Tube shelterers medicine to prevent flu as they take cover in at St John's Wood Tube Station.

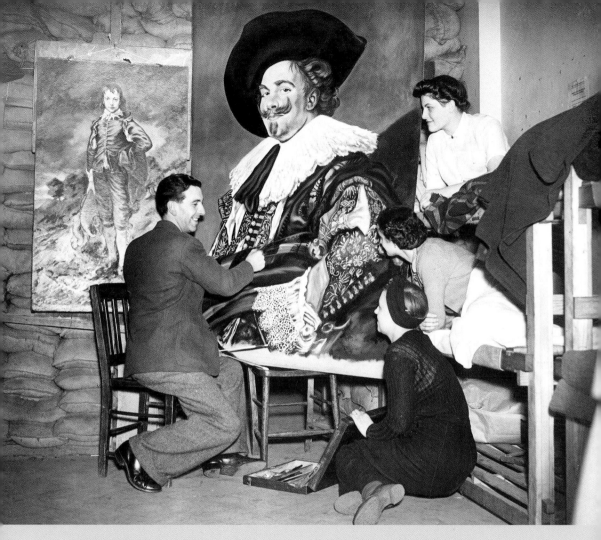

▲ **February 1941.** An artist paints a copy of the famous 'Laughing Cavalier' whilst sheltering underground.

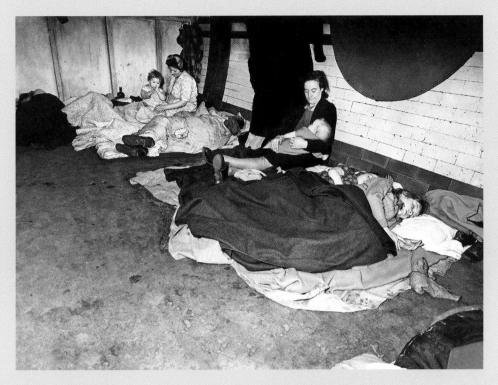

▲ **November 1943.** A woman feeding her child in an Underground station.

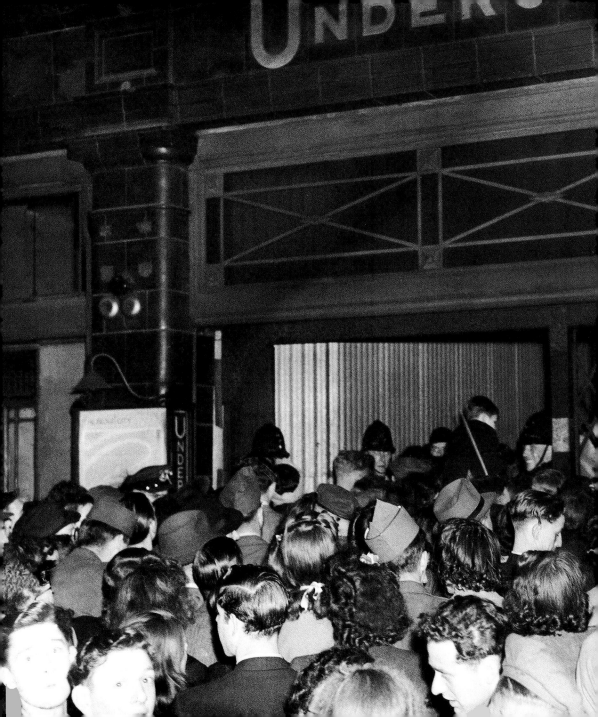

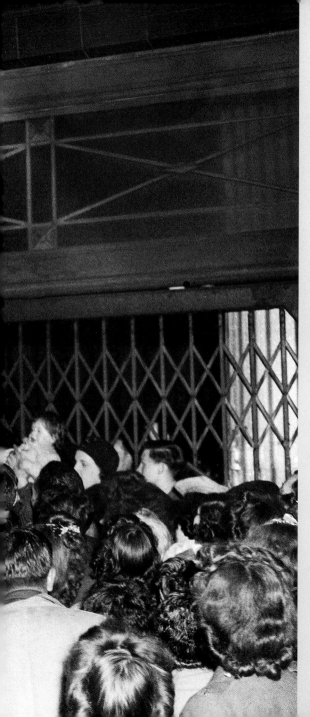

◄ **8 May 1945.** Huge crowds gathered outside an Underground station during the VE Day celebrations.

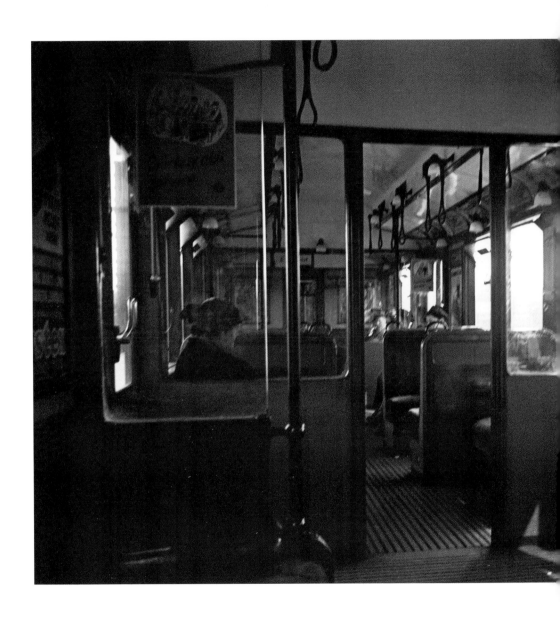

◀ The interior of a London Underground carriage, circa 1946.

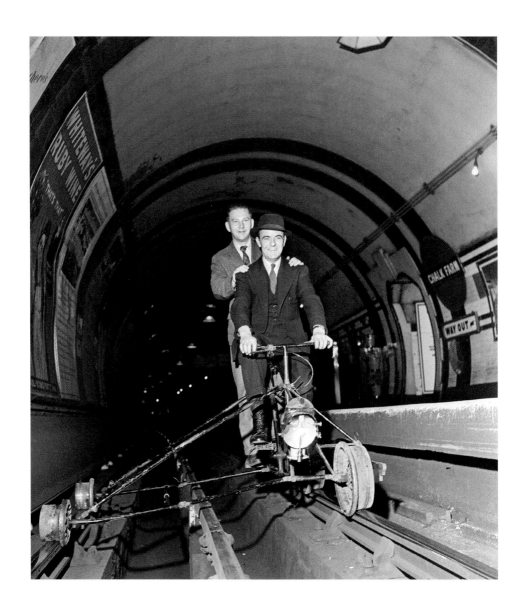

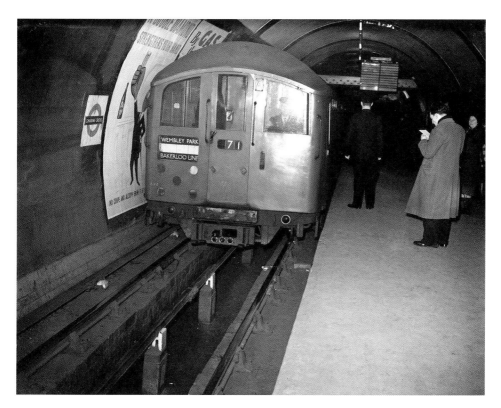

▲ **10 November 1950.** Charing Cross Underground Station platform.

◀ **24 August 1949.** Mr B.F. Harris on a specially constructed cycle on which he makes his nightly inspection of the Underground.

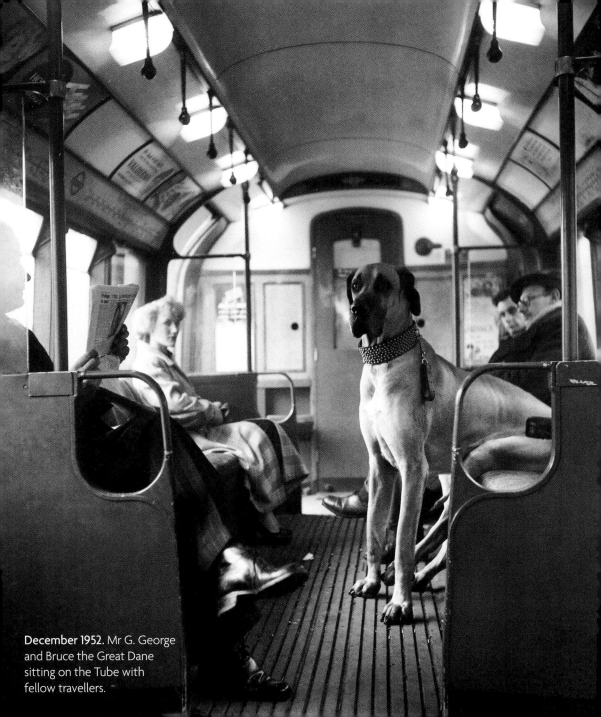

December 1952. Mr G. George and Bruce the Great Dane sitting on the Tube with fellow travellers.

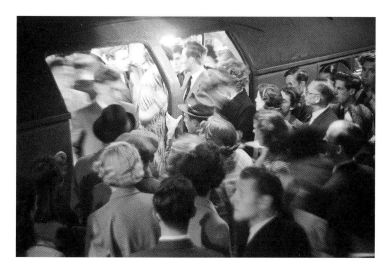

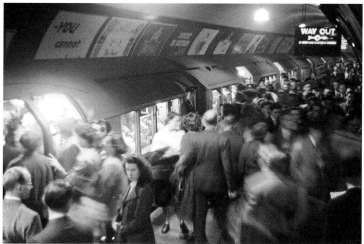

▲ **July 1953.** Overcrowding on the Central Line platform during rush hour at Liverpool Street Station.

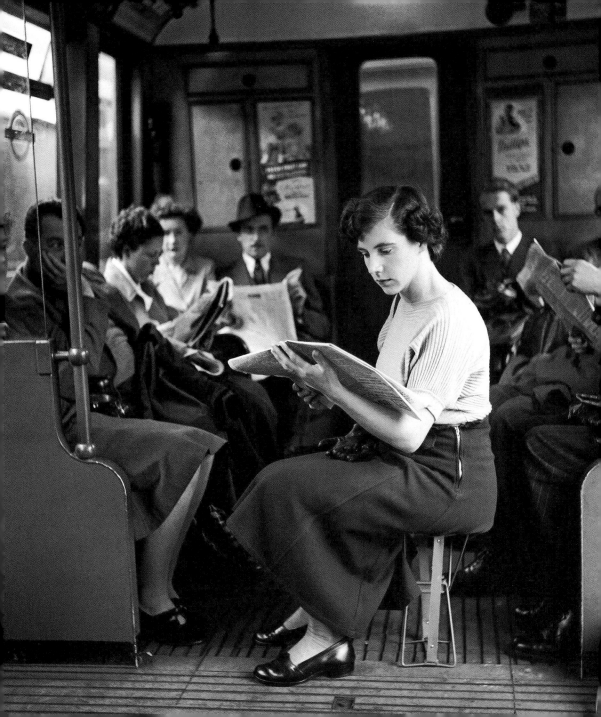

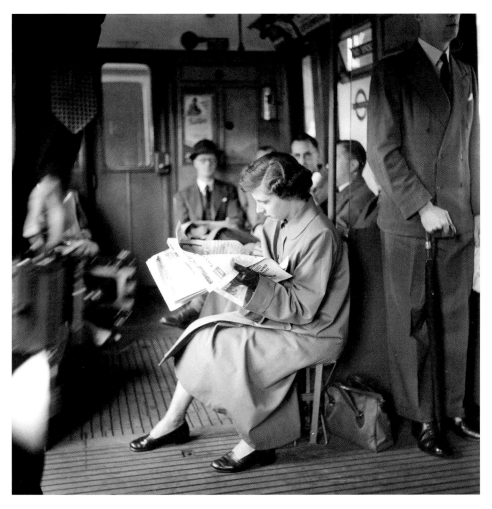

◀ ▲ **July 1953.** Mrs June Clark of Avenscroft Road, Chiswich, takes a stool with her when she travels to and from work. She says, 'Men just won't give up their seats to women nowadays, so I decided a few weeks ago to carry my own.'

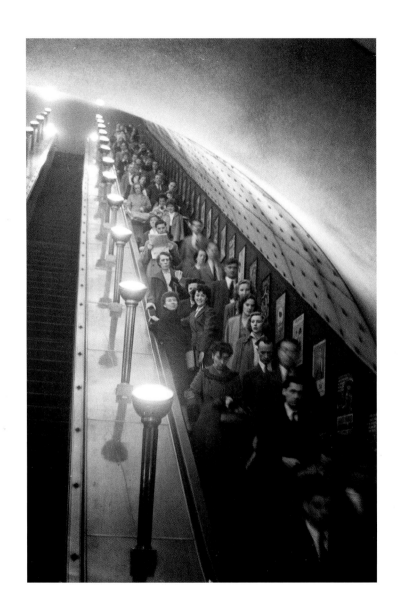

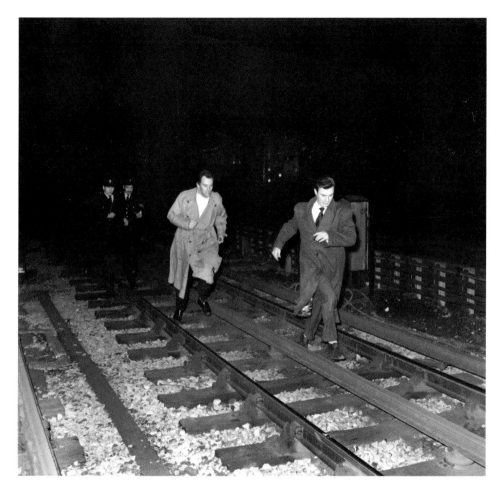

▲ **November 1953.** Lawrence Harvey (front) and John Ireland being chased by police along the train line in a scene from the film *The Good Die Young*.

◀ **July 1953.** Commuters taking the escalator down to the Central Line during rush hour at Liverpool Street Station.

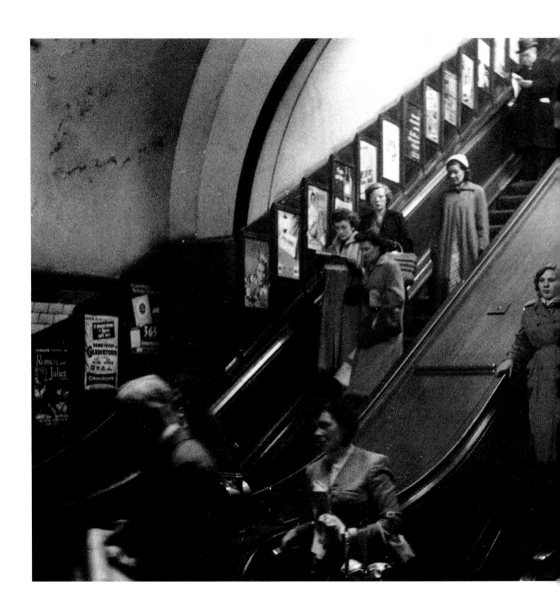

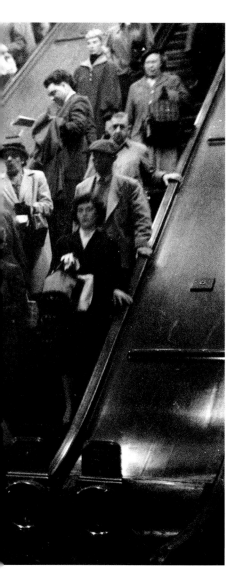

◀ **October 1954.** Scenes at Holborn Station.

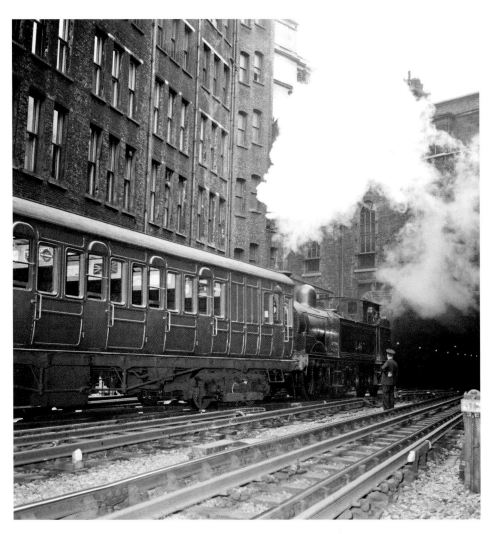

▲ **23 September 1957.** The 50-year-old steam train L46 took a party of train enthusiasts on a trip around the inner circle.

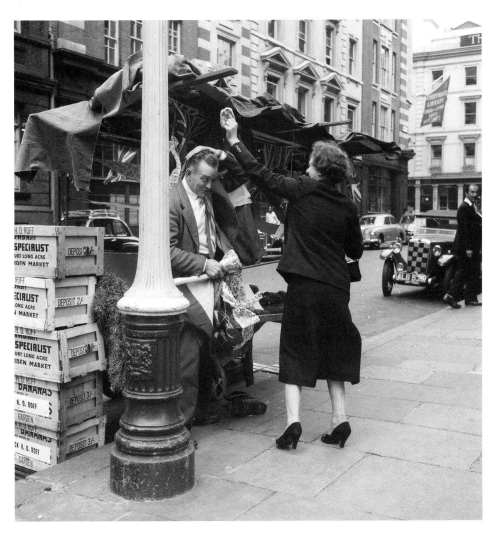

▲ **6 August 1958.** A barrow boy's decorated stall on the eve of his wedding, outside Charing Cross Station.

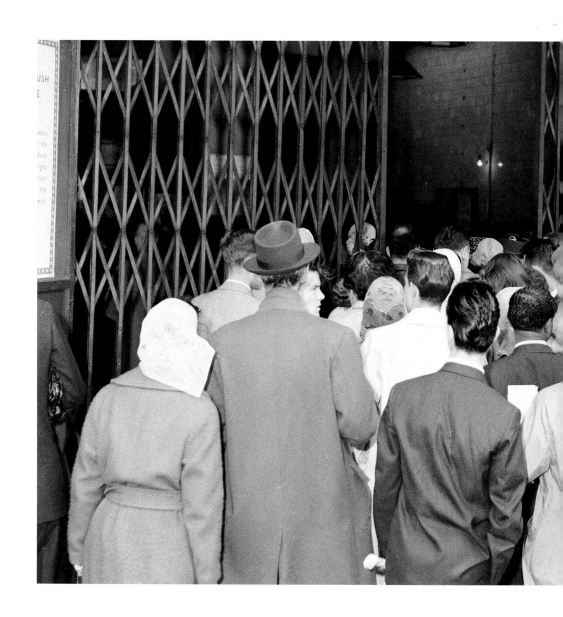

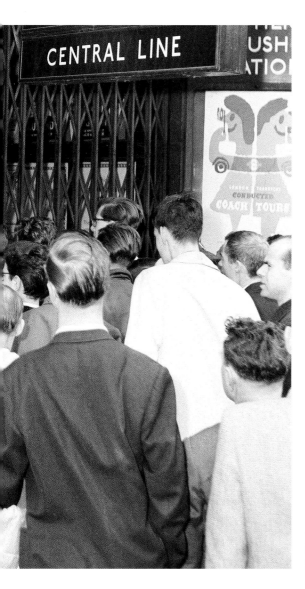

◄ (and overleaf) **11 July 1960.** Power station strikes, heavy rain and rush hour cause chaos at Shepherd's Bush and Oxford Circus Stations.

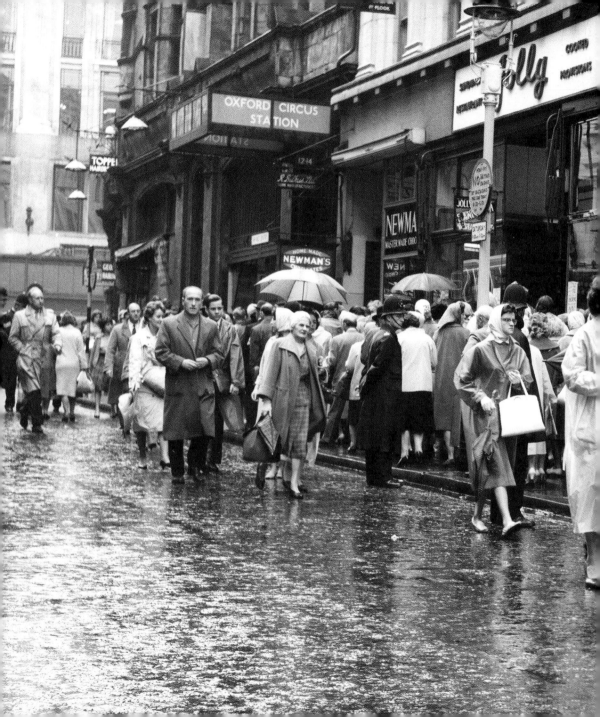

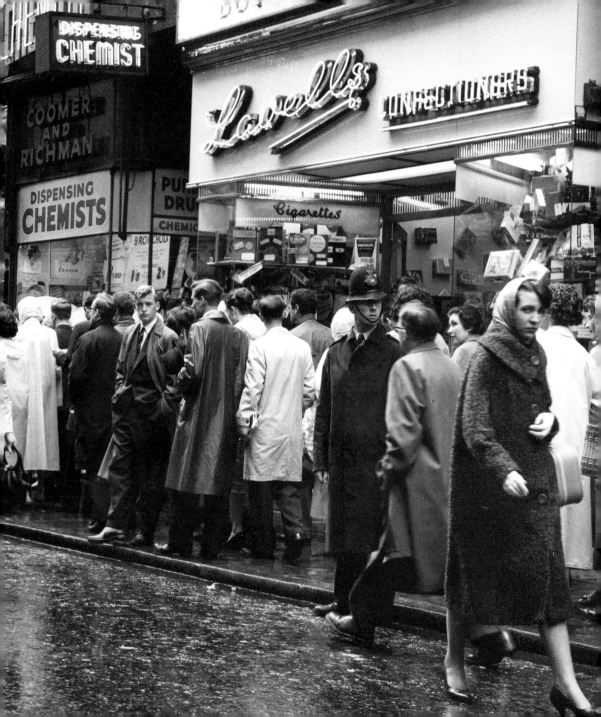

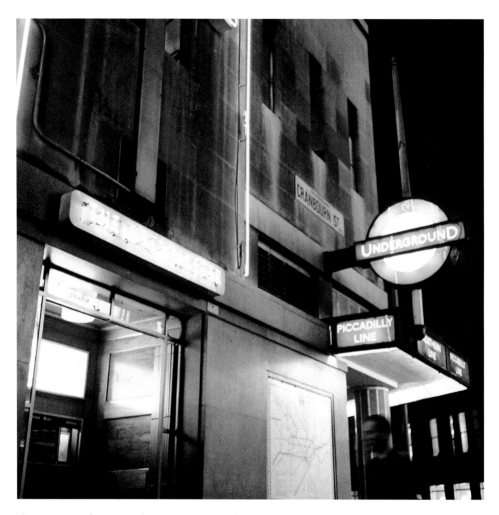

▲ **22 September 1961.** The Brewmaster pub and Leicester Square Tube on the corner of Cranbourn Street.

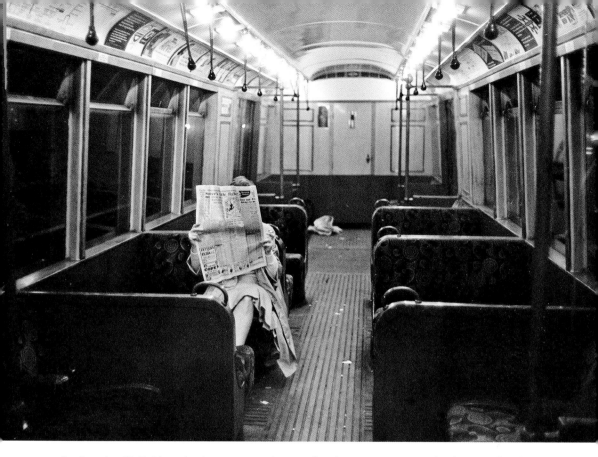

▲ **October 1962.** It's strike day at Farringdon Road and Euston Square, and only a couple of people are on the Metropolitan Tube train.

▲ **October 1962.** Another shot of the Metropolitan Line's strike day.

▶ **April 1963.** A guard at the controls of one of the new automatic trains.

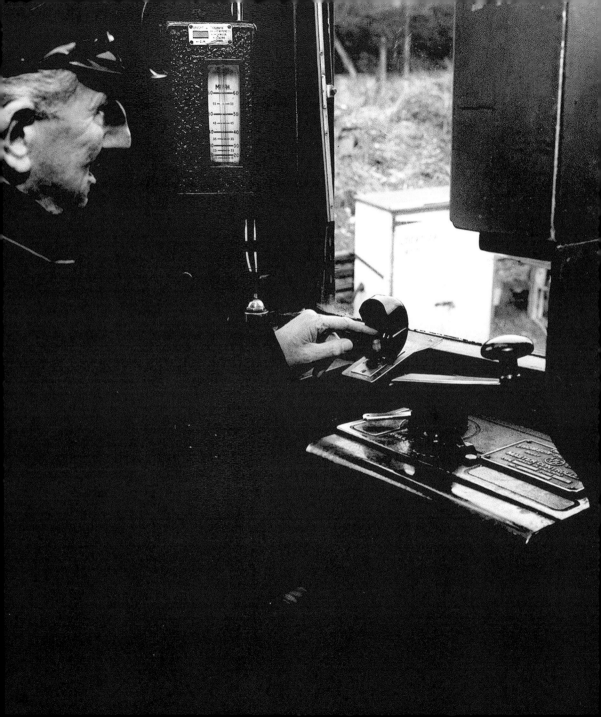

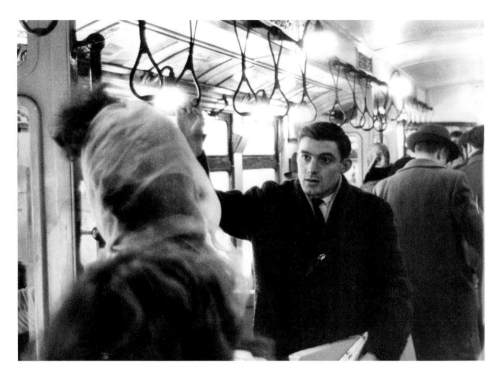

▲ **February 1963.** Bobby Tambling, one of Chelsea and England's highest-earning forwards, takes public transport to work from his home in Malden, Surrey.

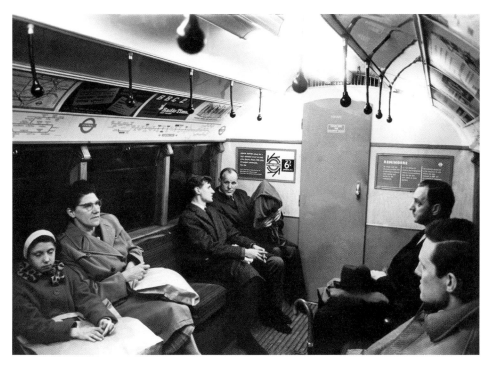

▲ April 1964. The quiet man holding a parcel on the Tube train goes unnoticed. He is Ron Greenwood, manager of West Ham, and the parcel contains the FA Cup, which is making its first Tube journey. Ron, the team and the cup have been to a film showing of the game, after which Ron returns to West Ham by Tube.

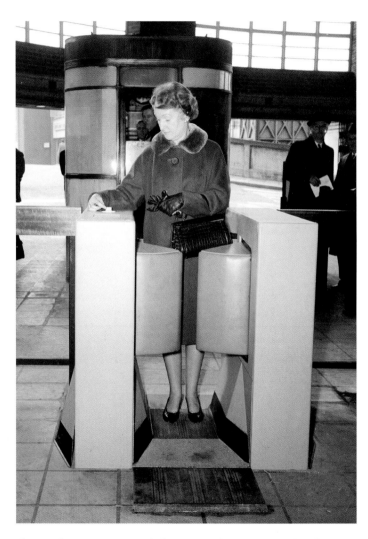

▲ **March 1964.** Miss May Shelton, a London Transport clerk from Earl's Court, tries the new automatic barrier at Chiswick Park Station.

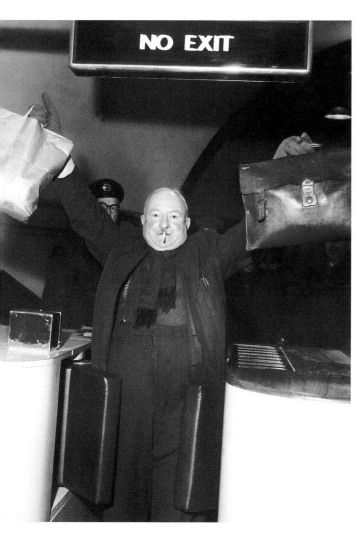

NO EXIT

◀ **January 1964.** The new robot ticket inspector at Stamford Brook Station is causing problems for Robert Beale. The £1,000 experimental machine checks tickets with a magic eye before a gate opens to let passengers through. However, it has already trapped several pregnant women, held up rush hour passengers and hemmed in those with handbags, briefcases or luggage. London Transport will have to iron out these teething troubles before the system is put into operation!

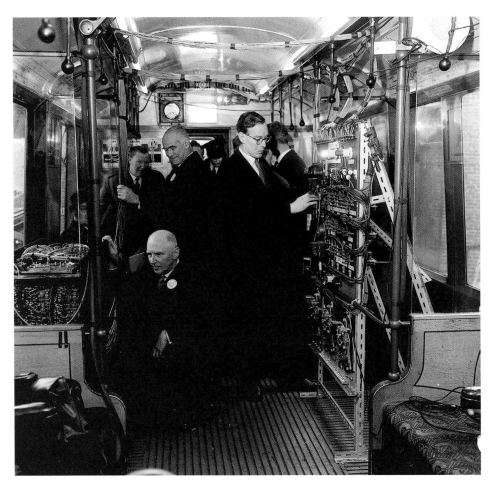

▲ **March 1963.** Technical staff monitor the performance of their new automatic train via instruments set up in the lead carriage during a test run.

▶ (and overleaf) **29 October 1964.** Construction of the Victoria Line under the streets of London.

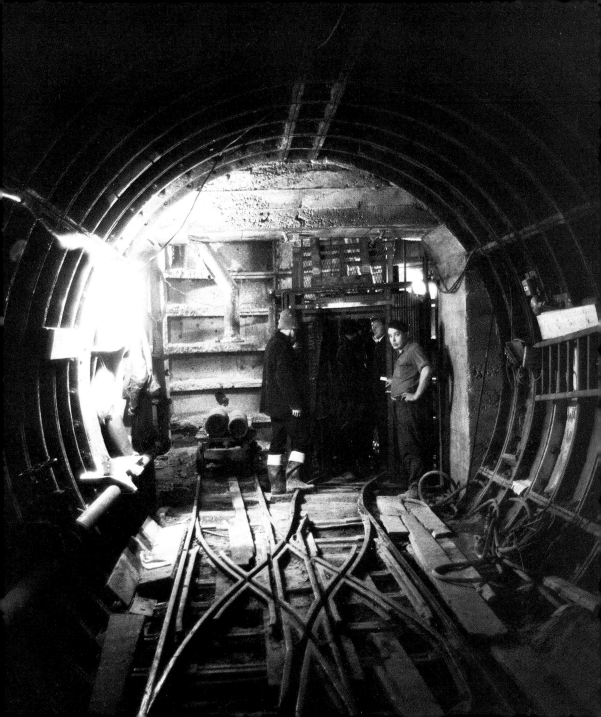

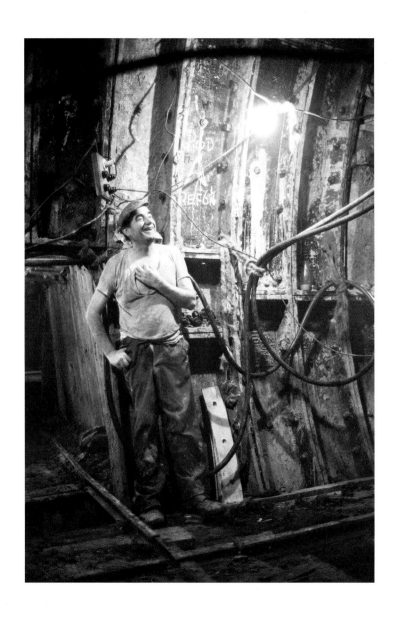

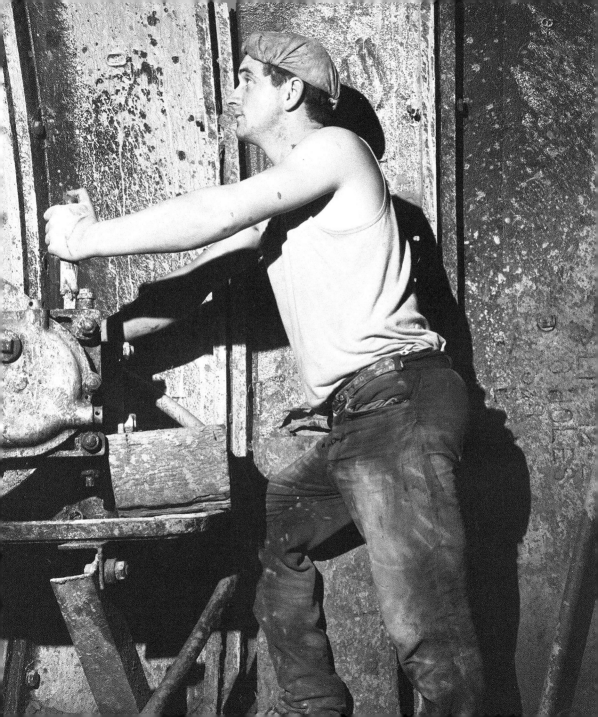

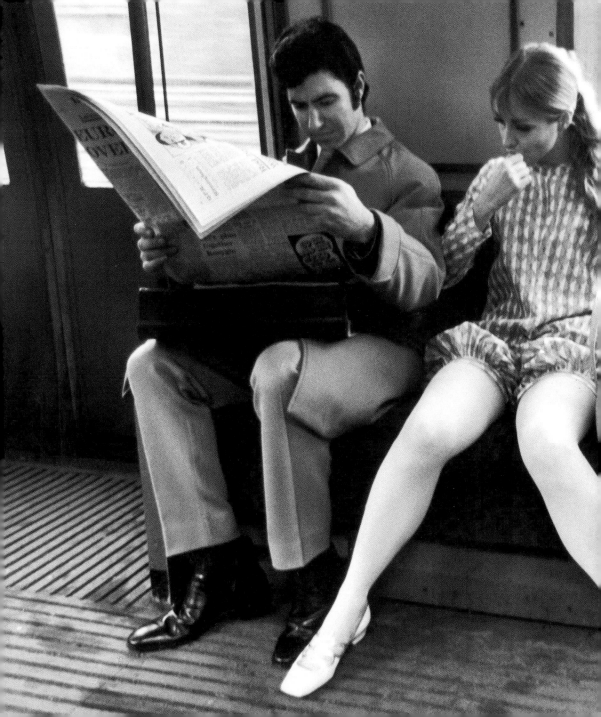

◀ **8 February 1967.** Model Jany Lewis wearing a Hildebrand bloomers outfit on the Circle Line.

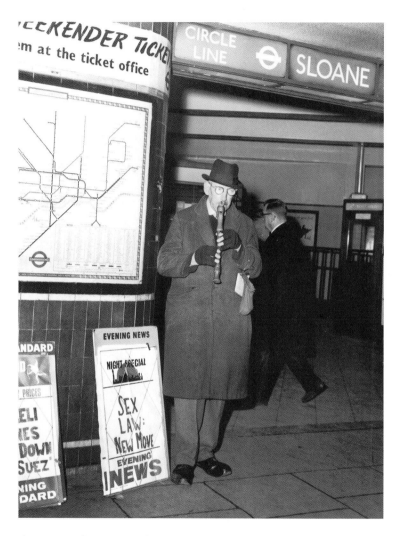

▲ **4 December 1967.** Busker George Russell playing his recorder outside Sloane Square Tube Station.

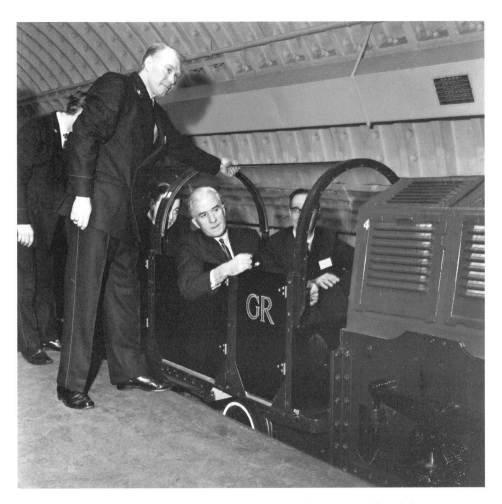

▲ **5 December 1967.** Her Majesty's Postmaster General, the Rt Hon. Edward Short MP, opening an exhibition to mark the 40th anniversary of the GPO railway. Mr Short is travelling by the Post Office railway from Mount Pleasant Post Office to King Edward's Building in the City, a distance of 1,495 yards.

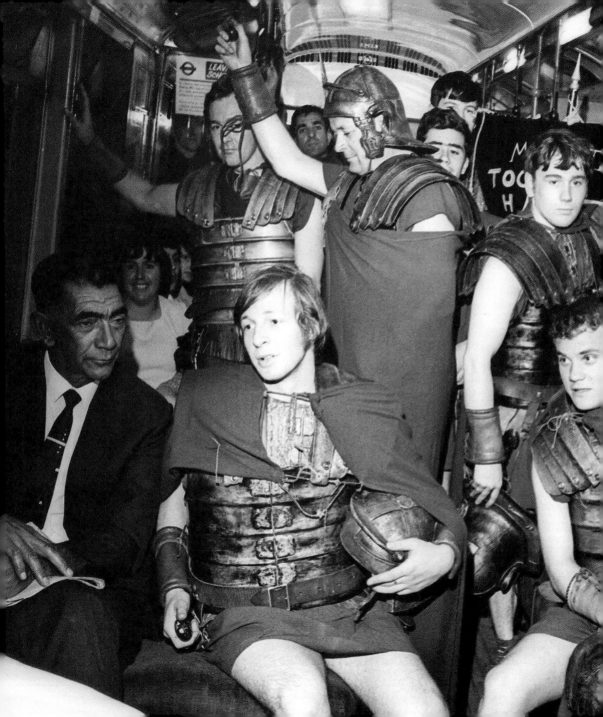

◀ July 1968. Men dressed as Roman soldiers on the Tube.

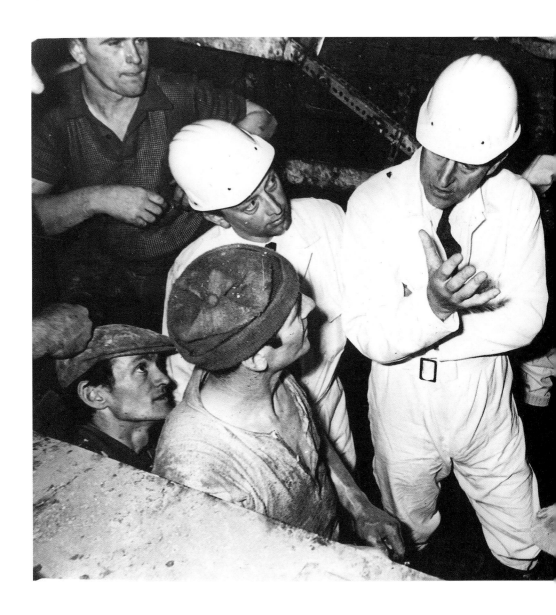

◀ **July 1968.** Prince Philip, Duke of Edinburgh, chats to a group of workers on his visit to the tunnel being built underneath Vauxhall Park during the construction of the new Victoria Line.

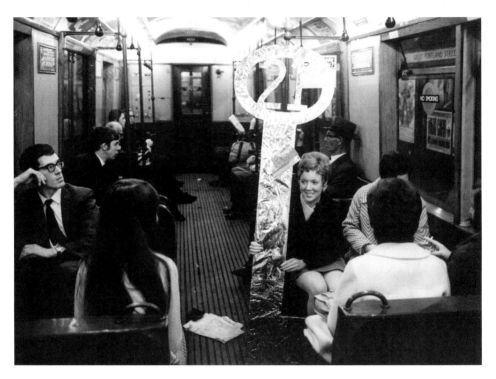

▲ **October 1968.** Rosemarie Porter, with a large 21st birthday key given to her by her workmates, gets strange looks while travelling home.

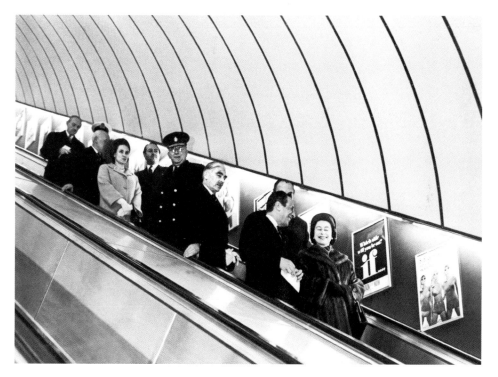

▲ **10 March 1969.** The Queen opens the Victoria Line.

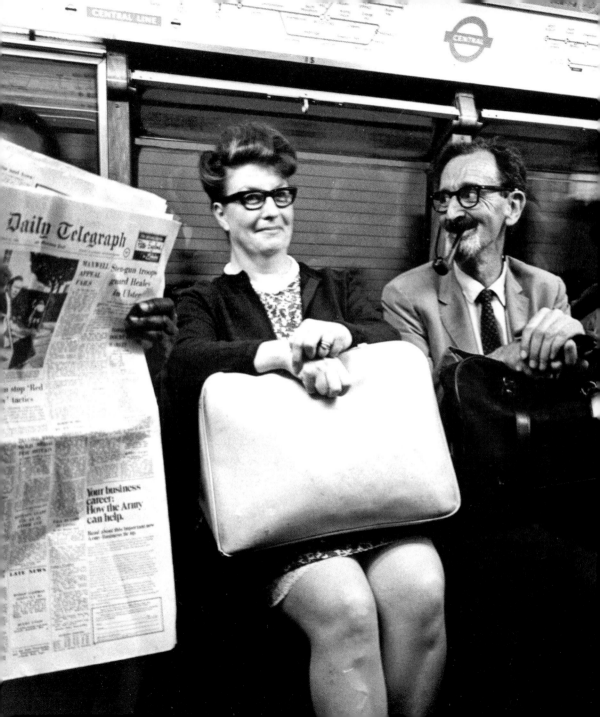

◄ **September 1969.** A man smoking a pipe pulls a face at his travelling companion.

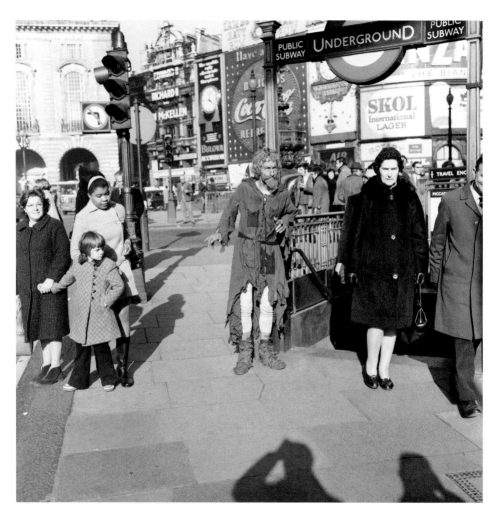

▲ **6 February 1970**. A photo call for *Catweazle* – a new LWT children's television series about an eccentric eleventh-century wizard (Geoffrey Bayldon) who accidentally travels through time to the year 1969 – in Piccadilly.

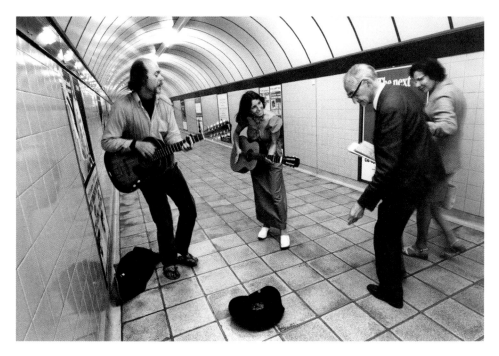

▲ July 1970. London's buskers are going underground. Each day they go down to the maze of tunnels at stations in the Underground railway network. Tube thumpers Irv Mowray from America, and his partner Sylvia 'Gigi' Tarnesby, who hope to break into the recording business, are strumming up the pennies in a Tube tunnel.

Overleaf: July 1970. Underground singers on a Victoria Line train. From left to right: Jane Pooler-Williams, Roy, Keith Bunney (with glasses), Sylvia Tarnesby, Susan Nitschke, Alan Brereton, Jan Ballard, Eric, Thomas McDonald and Bob Gillan.

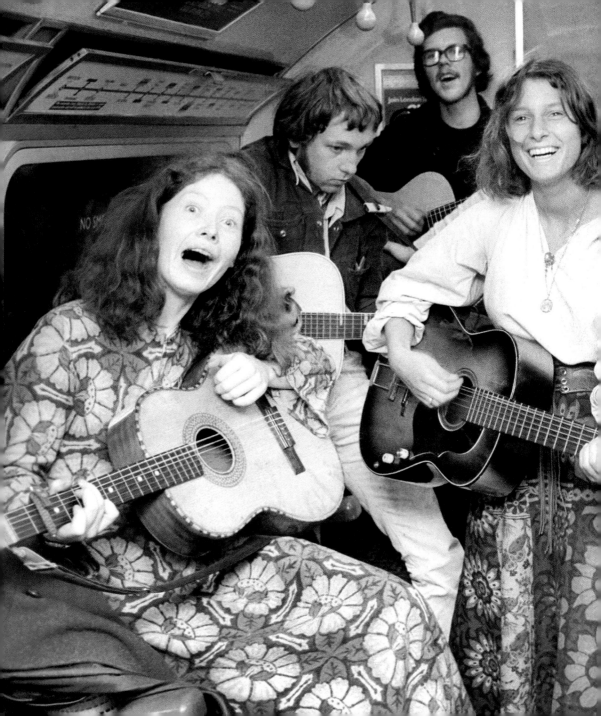

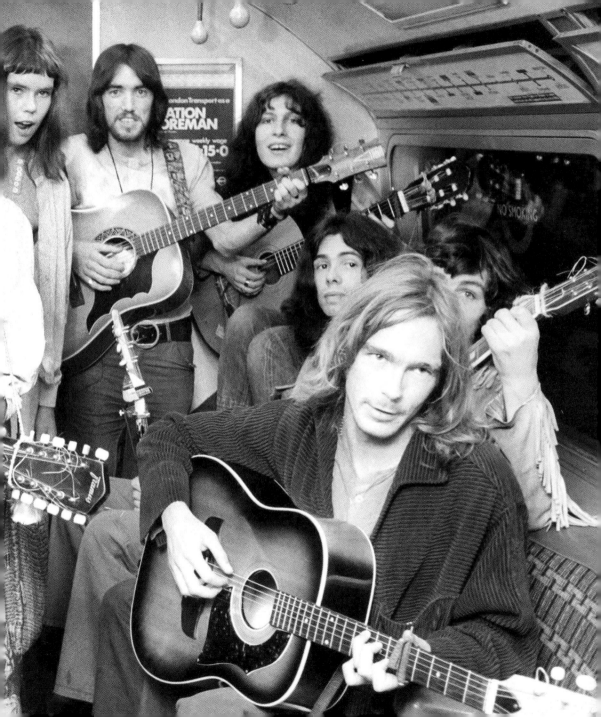

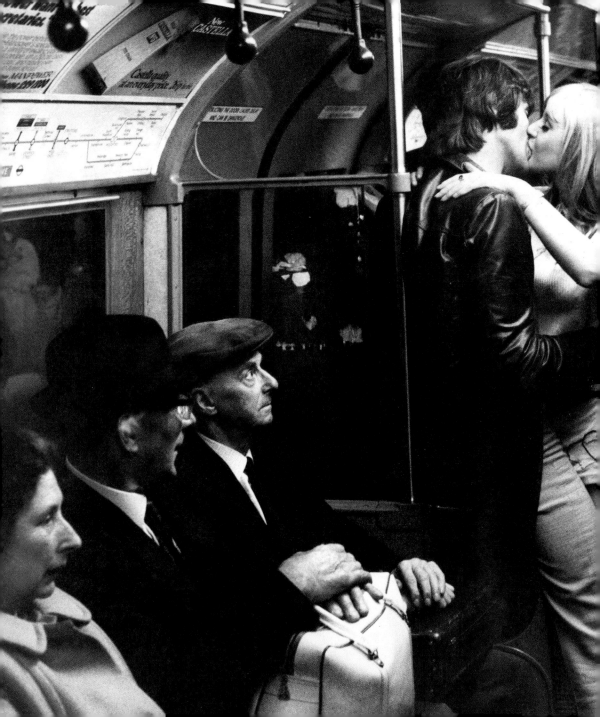

◀ **August 1971.** You get there quicker by Tube, they say.

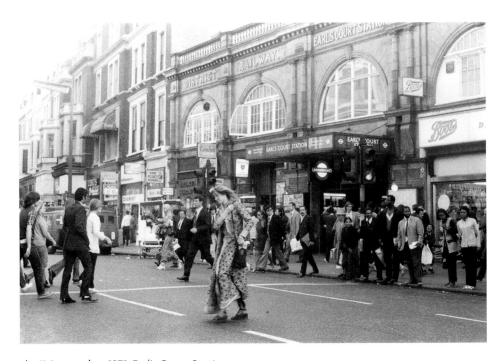

▲ **11 September 1971.** Earl's Court Station.

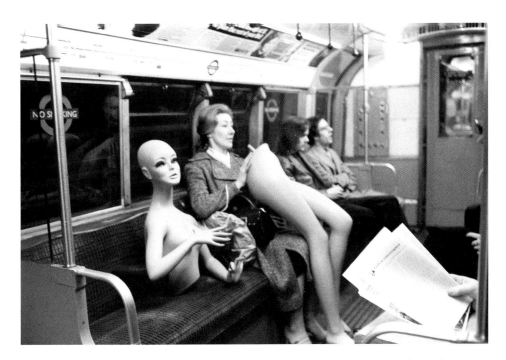

▲ **12 April 1972.** Lorna Scott, who is stage-managing a production for a South London amateur dramatic society, carrying a life-sized display dummy home after collecting it from a shopfitters.

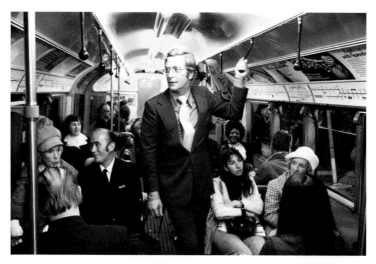

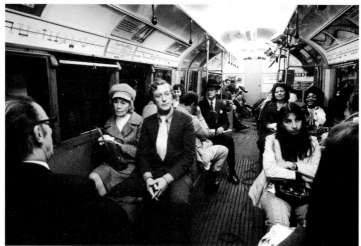

▲ **29 July 1973.** Actor Michael Caine travelling on the Tube at Aldwych during filming for the film *Drabble*.

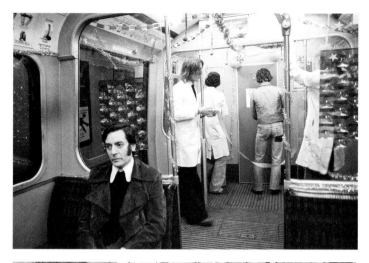

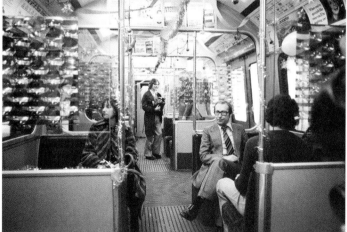

▲ **9 December 1974.** Students from the Central School of Art and Design decided that Christmas should come to the Underground, so they decorated a carriage on the Circle Line.

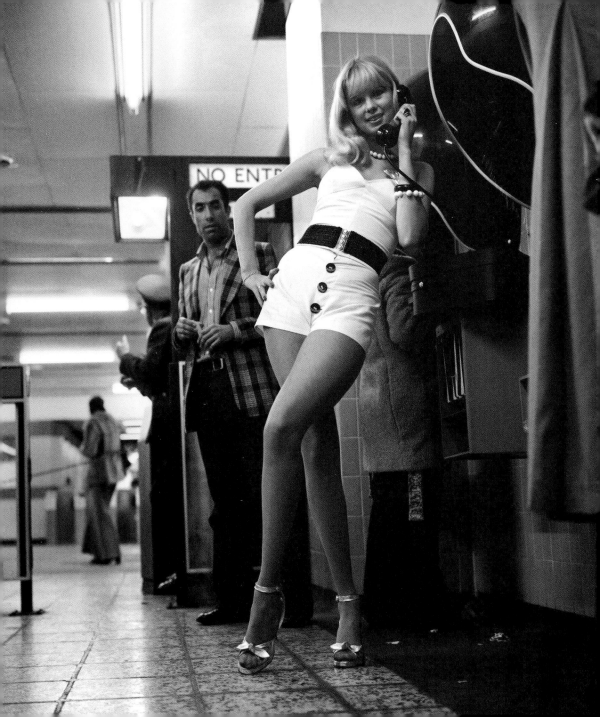

◄ January 1975. Model Christine Donna using the public telephones at Holborn Tube Station.

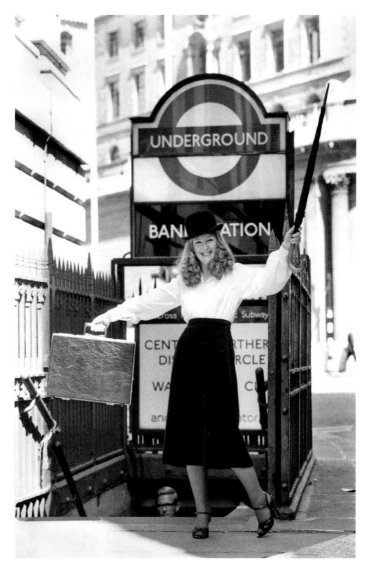

▶ August 1978. Andrea Mullancy, the Top Secretary of 1978, wearing a bowler hat and holding an umbrella outside a Tube station.

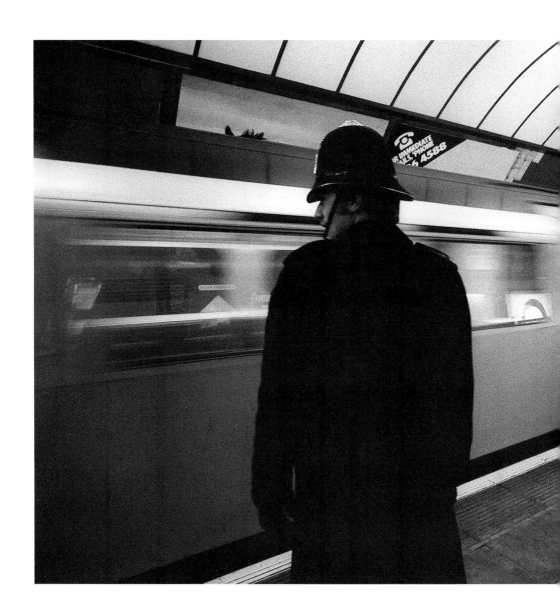

◀ **March 1976.** Following a series of terrorist attacks across the capital, a policeman patrols a platform on the Underground.

MOORGATE CRASH

The Moorgate Tube crash occurred on Friday 28 February 1975 at 08.46 a.m. on the Northern Line (Highbury Branch). A southbound train failed to stop at the Moorgate terminus and crashed into the wall at end of the tunnel. Forty-three people died as a result of the crash and a further seventy-four were injured. No fault was found with the train equipment, and the Department of the Environment report found that the driver had failed to slow the train and stop at the station, but there was insufficient evidence to determine the cause, as the driver died in the crash.

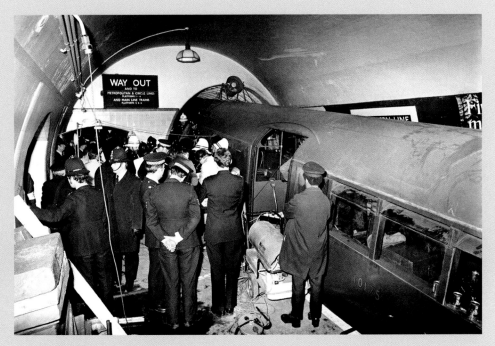

▲ Northern Line Tube crash at Moorgate Underground Station.

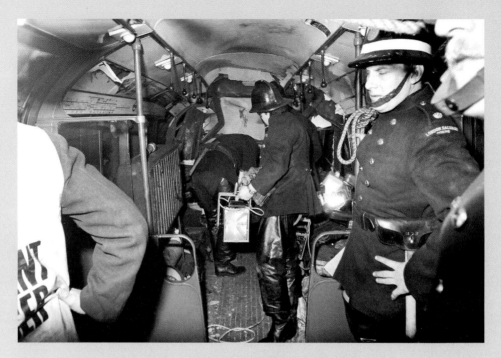

▲ Northern Line Tube crash at Moorgate Underground Station.

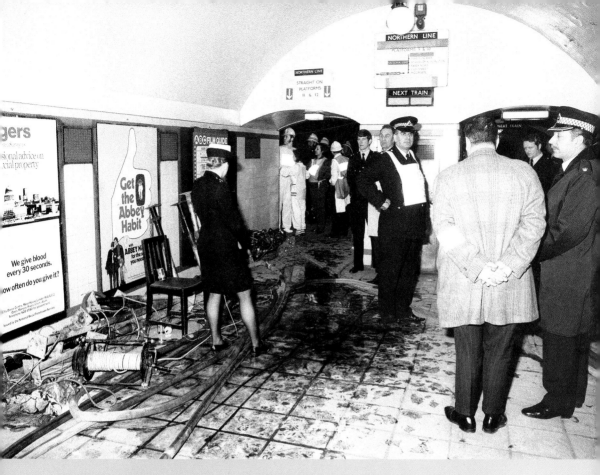

▲ The scene at the entrance to Platform 9, where rescue workers try to free passengers from the wreckage.

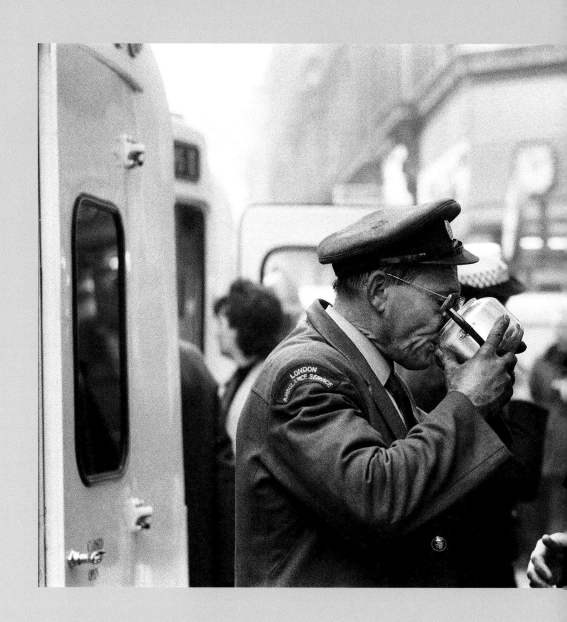

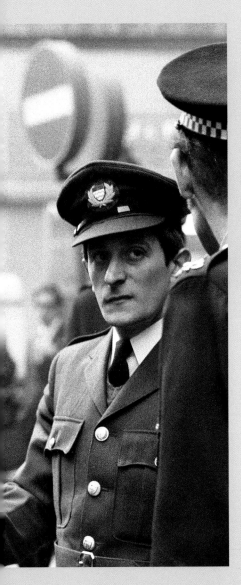

◀ A London Ambulance man takes a quick tea break to steady himself after bringing casualties up from the platform below.

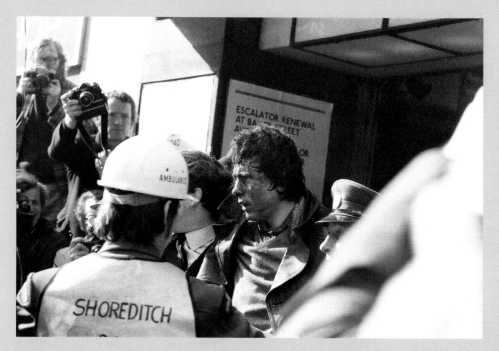

▲ One of the injured being helped to an ambulance.

▲ One of the passengers, with minor injuries, leaving hospital following treatment.

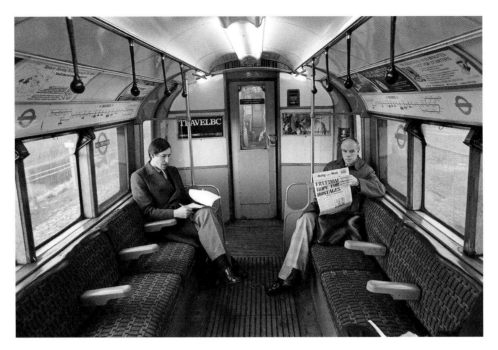

▲▶ **March 1980.** An all-but-deserted Central Line Tube between Epping and Ongar.

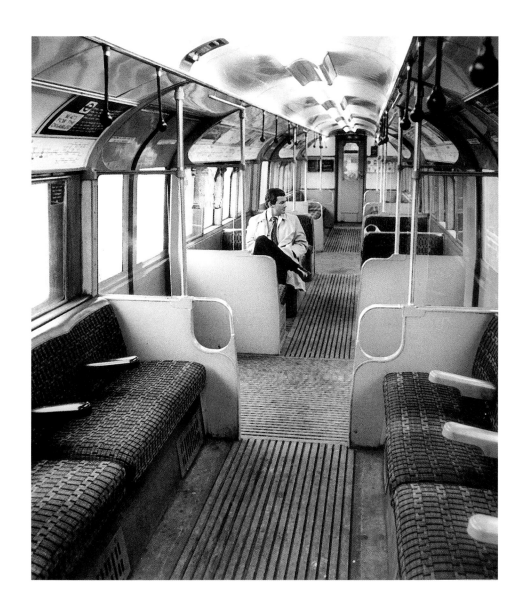

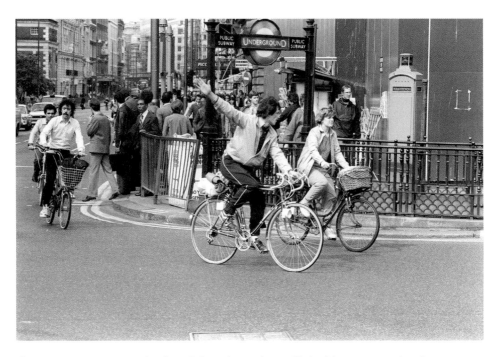

▲ **June 1982.** Scenes on the day of the Tube strike: traffic builds up as people take to their bicycles.

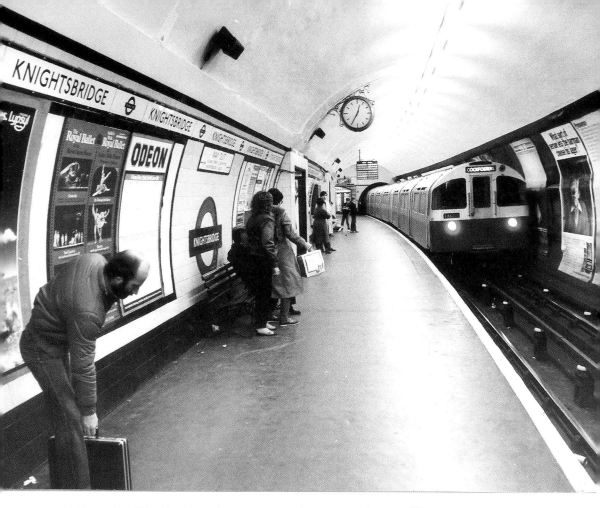

▲ **December 1982.** Knightsbridge Underground Station on the Piccadilly Line.

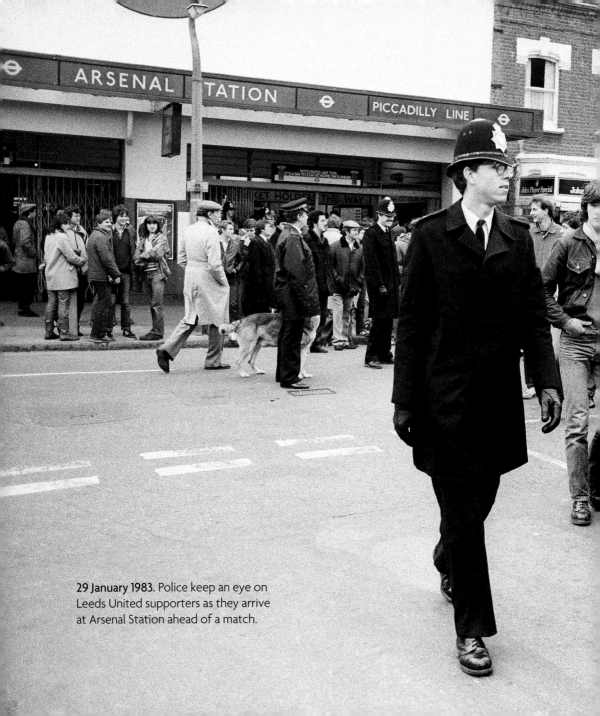

29 January 1983. Police keep an eye on Leeds United supporters as they arrive at Arsenal Station ahead of a match.

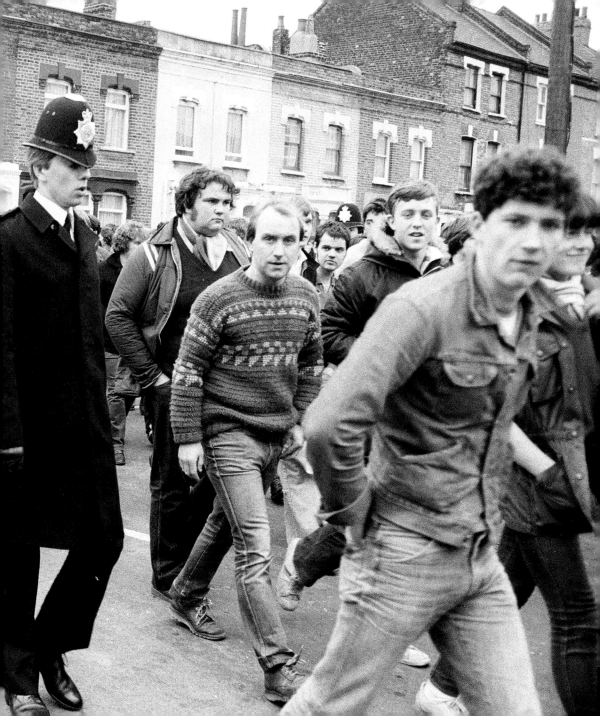

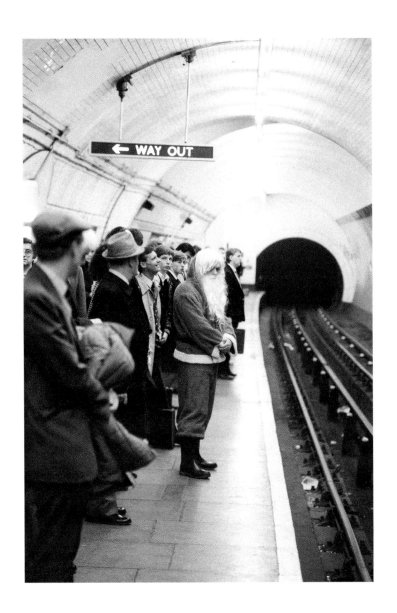

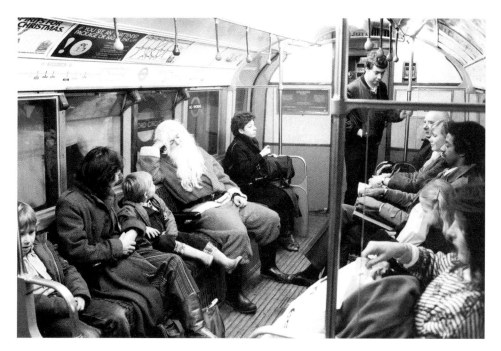

◀▲ **20 December 1984.** Father Christmas, of Bentall's Store, Ealing, takes the Tube to pick up his sleigh. The commuters do not seem fazed.

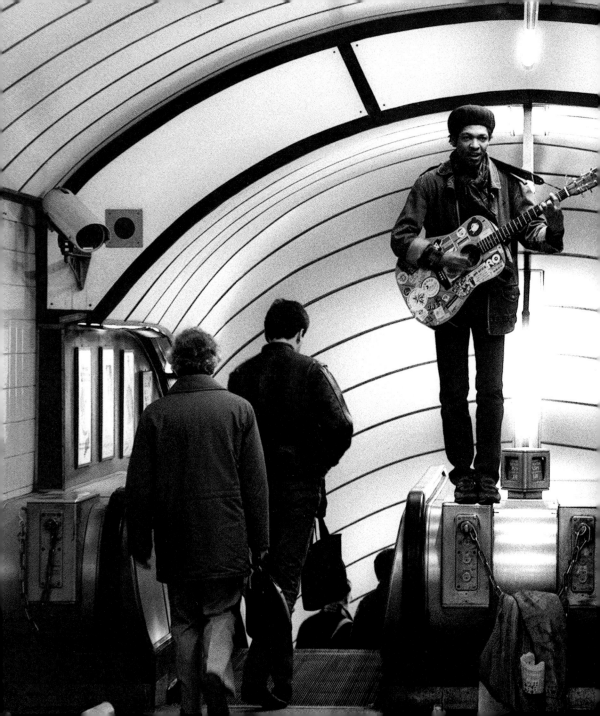

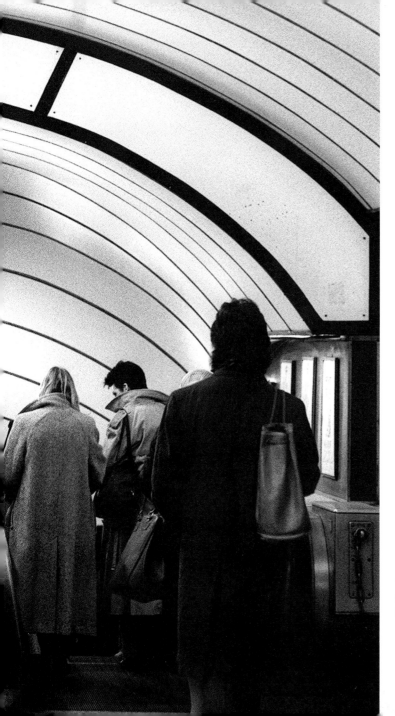

◀ February 1987.
A musician busking at
Oxford Circus Station.

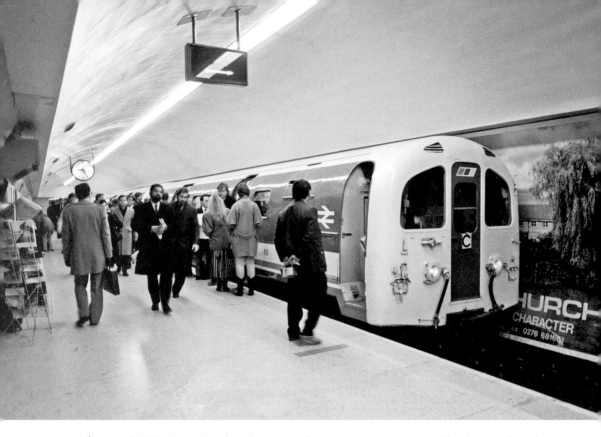

▲▶ **March 1987.** A new British Rail train seen here at Moorgate Station. The design is based on the London Transport Tube trains.

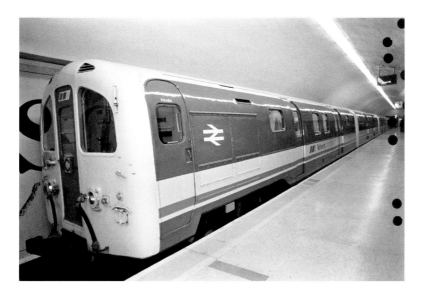

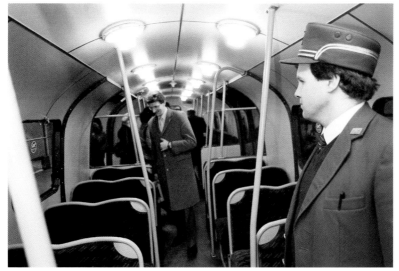

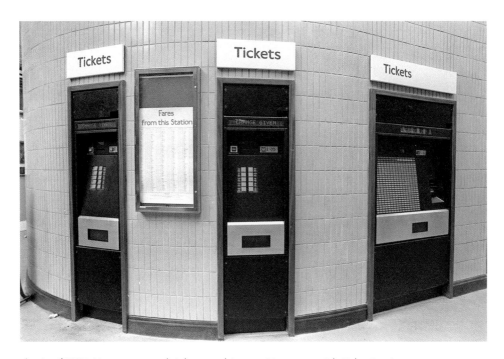

▲ **April 1987.** New armoured ticket machines at Hammersmith Tube Station.

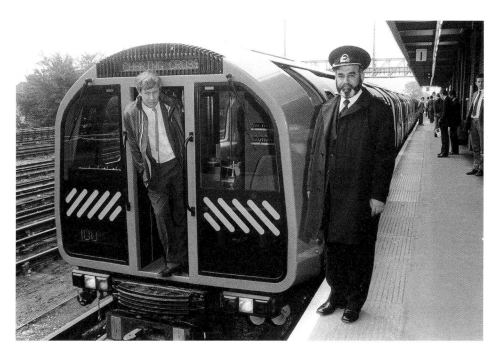

▲ **June 1987.** A new Tube train is launched at the platform of a Metropolitan Line station; standing alongside the train is the station master.

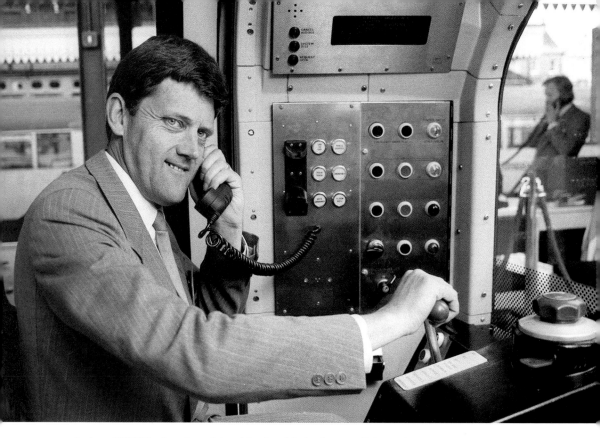

▲ **June 1987.** The interior of the driver's cabin in the new Tube train.

▲ **November 1987.** A train approaches the platform at Heathrow Airport's Terminal Four Underground Station on the Piccadilly Line.

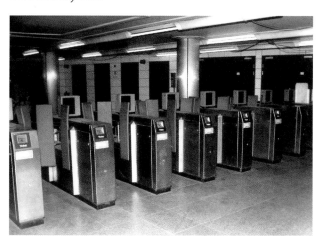

▲ **November 1988.** New ticket barriers at Chancery Lane Station.

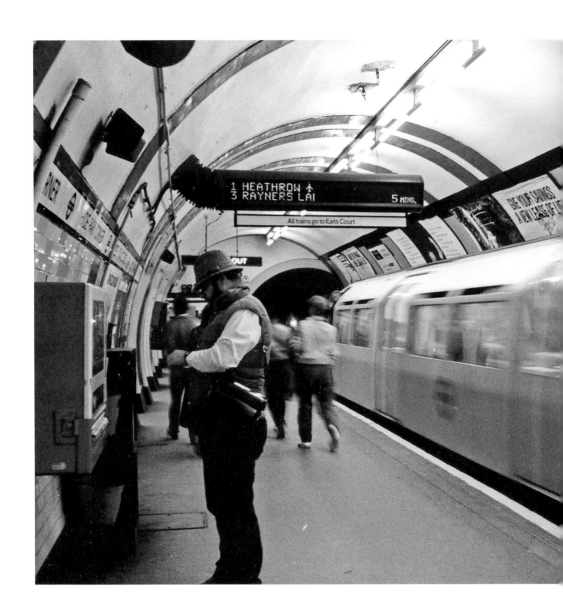

◀ **December 1988.** Hyde Park Corner.

KING'S CROSS FIRE

At about 7.30 p.m. on 18 November 1987 several passengers reported seeing a fire under a Piccadilly Line escalator. Staff and police went to investigate and, on confirming the fire, one of the policemen went to the surface to radio for the fire brigade, as the fire was beneath the escalator and it was impossible to get close enough to use a fire extinguisher. The decision to evacuate the station was made at 7.39, using the Victoria Line escalators. A few minutes later the fire brigade arrived, and several firemen went down to the escalator to assess the fire. They saw a fire about the size of a large cardboard box and plans were made to fight it with a water jet, using men with breathing apparatus.

Six minutes later, at 7.45, a jet of flames came up the Piccadilly escalator shaft, filling the ticket hall with intense heat and thick black smoke, killing or seriously injuring most of the people there. Several hundred people became trapped below ground: most of these passengers escaped on Metropolitan and Victoria Line trains.

Thirty fire crews, with over 150 firefighters, were deployed to fight the fire, and fourteen London Ambulance Service ambulances ferried the injured to local hospitals. Thirty-one people died and 100 people were taken to hospital, nineteen with serious injuries. The fire was only declared out at 1:46 the following morning.

Amongst the dead was Fire Brigade station officer Colin Townsley, who was in charge of the first fire engine to arrive at the scene and was down in the ticket hall at 7.45 p.m. His body was found beside that of a badly burnt passenger at the base of the exit steps to St Pancras Road – it is believed that Townsley spotted the passenger in difficulty and stopped to help her.

The fire was most probably caused by a lit match being dropped onto the escalator.

Overleaf: The ticket hall of King's Cross Station after the fire.

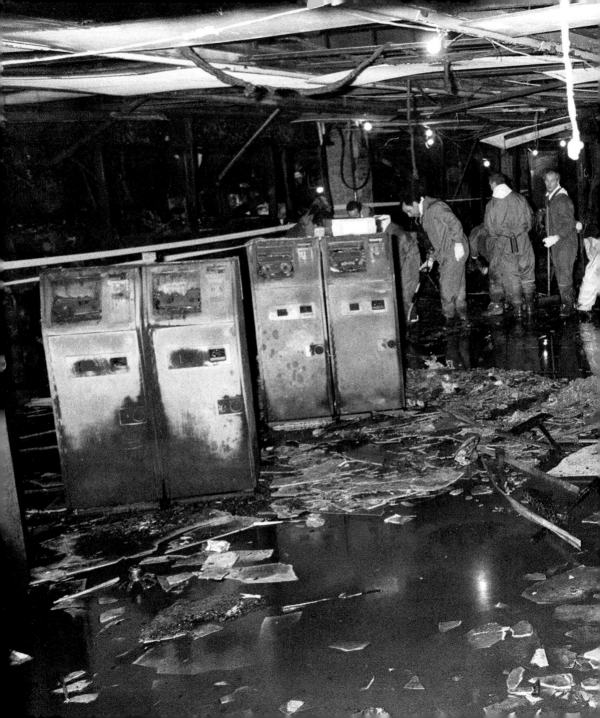

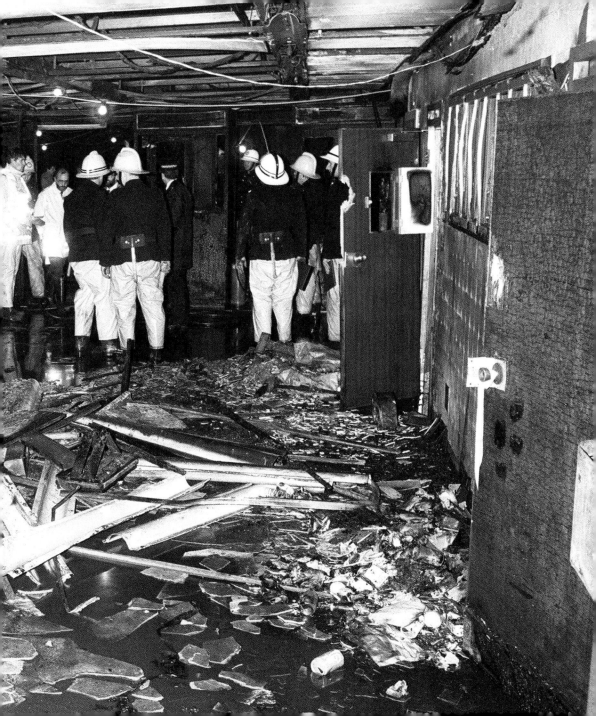

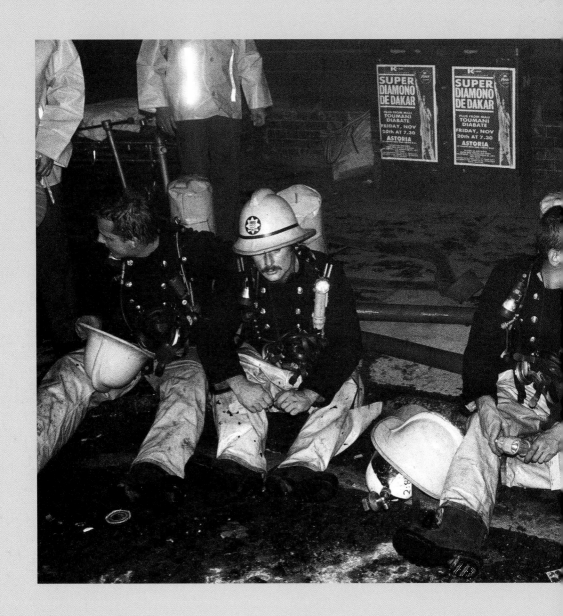

KING'S CROSS FIRE

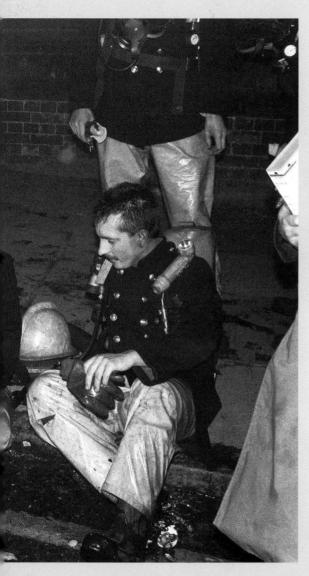

◄ Exhausted firemen taking a
break from fighting the fire below.

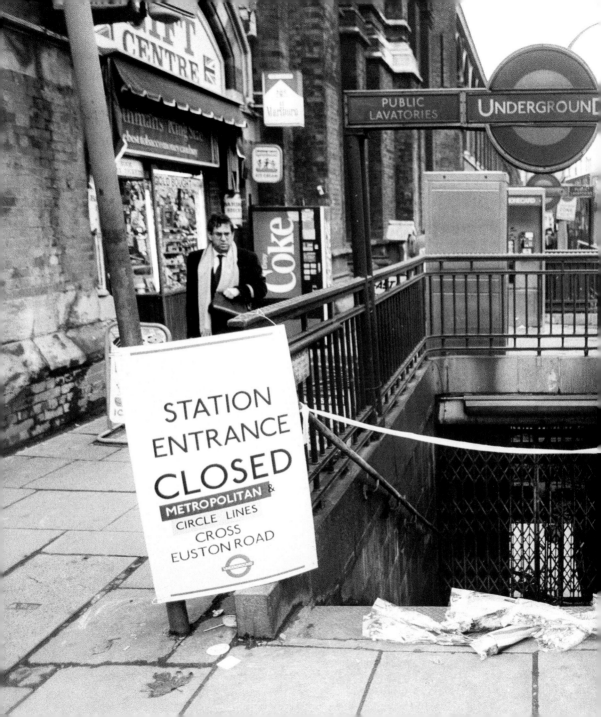

◀ King's Cross Station reopened in stages, with the final repairs finishing sixteen months later.

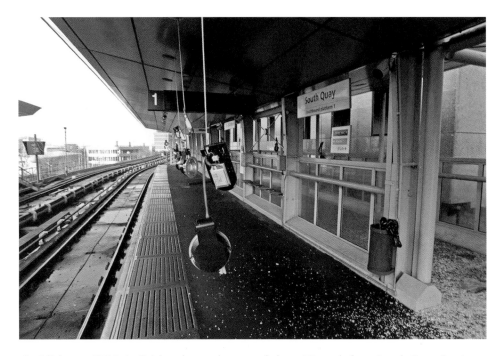

▲ **9 February 1996**. An IRA bomb was detonated about 70 yards from South Quay Station, killing two and injuring over 100. This is the damage left behind.

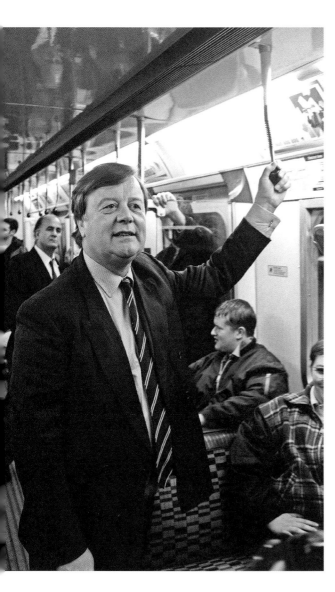

◀ **March 1997.** Former Chancellor of the Exchequer Kenneth Clarke on the District Line.

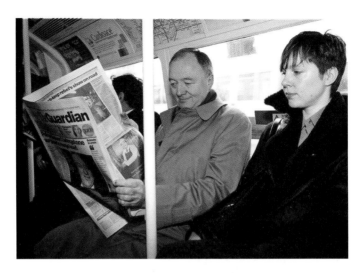

▲ **March 2000.** London mayoral hopeful Ken Livingstone at Willesden Tube Station.

▲ The Oyster card was first issued in June 2003. By 2012, 80 per cent of journeys in London were made using one.

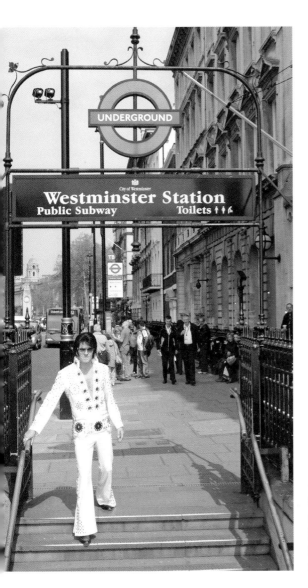

◀ **22 April 2004.** Theatre impresario Bill Kenwright claims that Elvis made a secret sightseeing trip to London in the 1950s. Elvis Presley impersonator Anthony Shore is visiting Westminster Tube Station to re-enact it.

7/7 BOMBINGS

On 7 July 2005, four bombs were set off by 'suicide bombers' on public transport: three on Tube trains and one on a bus, spaced out across the city. Fifty-two people were killed and over 700 were injured in one of the deadliest attacks on British soil. It came a day after the announcement that London was to hold the 2012 Olympic Games.

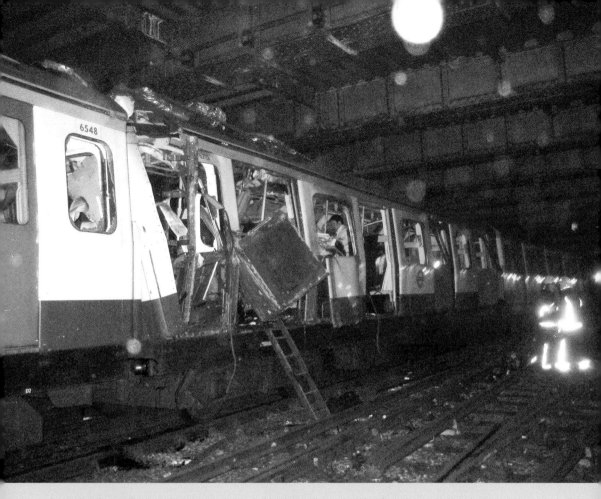

▲ **7 July 2005.** The Aldgate to Liverpool Street train seconds after the suicide bomb exploded. The picture was taken by Japanese language student Takayuki Kawashima, who boarded the train at 8.40 a.m.

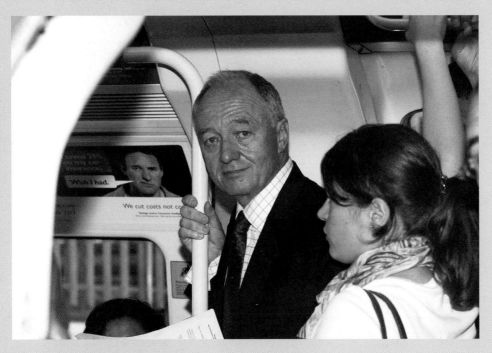

▲ **11 July 2005.** Days after the 7/7 attacks, London Mayor Ken Livingstone boards a Tube train on his way to work.

▶ 'The City Will Endure': Ken Livingstone's message on flowers at the remembrance ceremony in Victoria Gardens.

The City will endure. It is
the future of our world.
Tolerance and change

Ken Livingstone

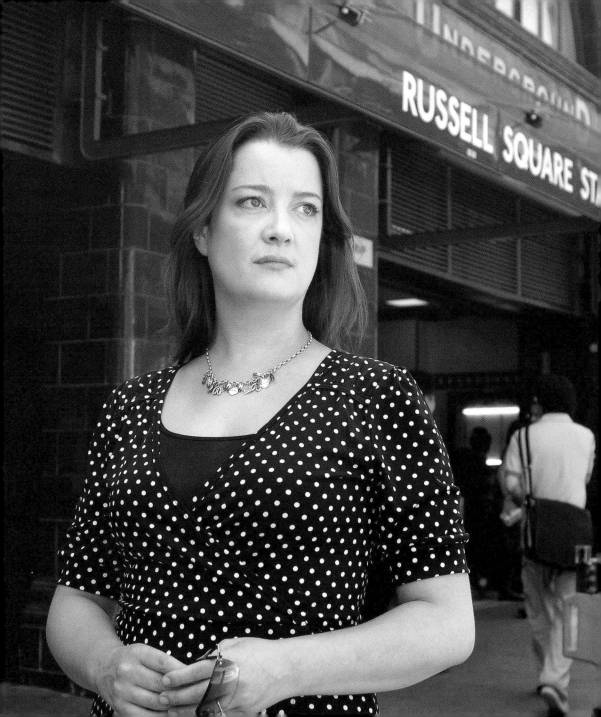

◀ **July 2006.** Rachel North outside Russell Square Tube Station, a year after she helped victims.

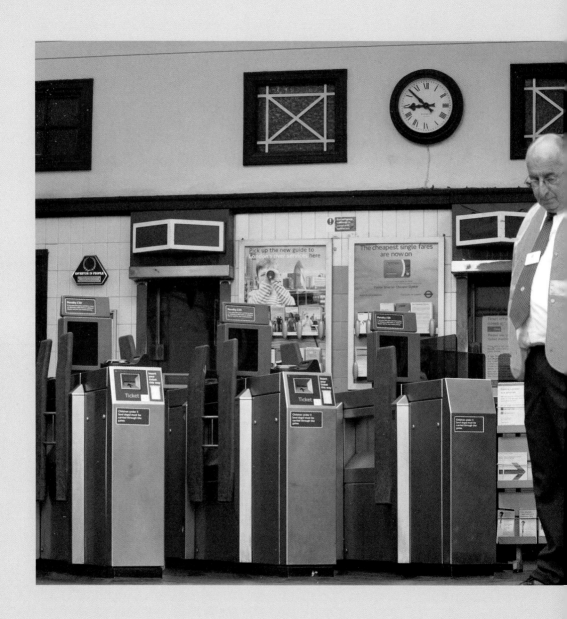

◀ July 2006. Derek Pemberthy (left) was duty station manager the day of the attacks. A year later at 8.50 a.m., they remember those lost.

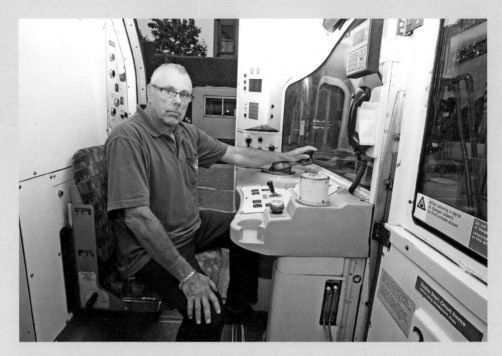

▲ July 2015. Ten years on: Stuart Bell was driving his Underground train on the Piccadilly Line when a bomb exploded on a train travelling in the other direction, and he rushed to help.

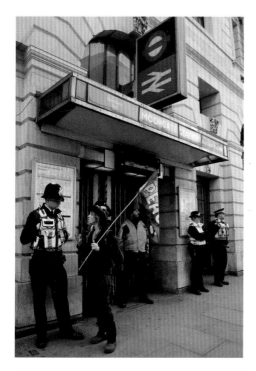

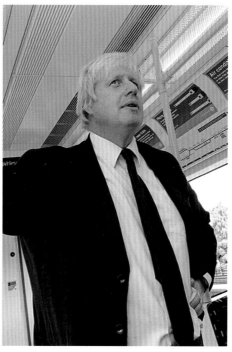

Clockwise from left: 30 March 2007. Not just for humans: Peaches Geldof's dog enjoys a ride at Oxford Circus Tube Station.

April 2009. A peaceful protester chats to police outside a closed Moorgate Station ahead of the march on the Bank of England.

2 August 2010. London Mayor Boris Johnson unveils the new air-conditioned Metropolitan Line train at Wembley Park Station.

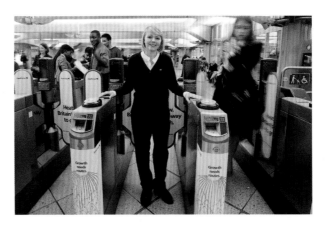

▲ **October 2011.** National Apprentice of the Year Shauni O'Neil, an 18-year-old station supervisor.

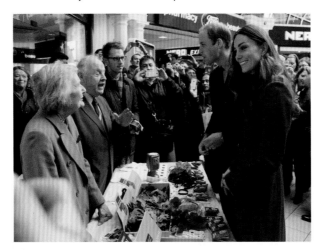

▲ **7 November 2013.** The Duke and Duchess of Cambridge join RAF personnel at Kensington Underground Station to sell poppies ahead of Remembrance Sunday.

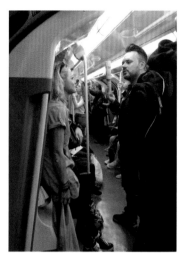

Clockwise from above: 23 March 2014. Posters outside an Underground station on the day of the funeral of Bob Crow, former leader of the National Union of Rail, Maritime and Transport Workers.

22 September 2014. Singer Jessica Taylor can't stop laughing after the press night of *Evita* at the Dominion Theatre.

24 June 2015. S Club 7 stars Hannah Spearritt and Paul Cattermole on the Tube to Stratford days after news of their relationship broke.

13 July 2016. Greg, a TfL worker with an eye-catching mohican hairstyle, helps customers at Oxford Circus.

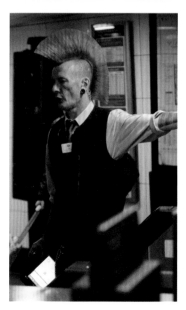

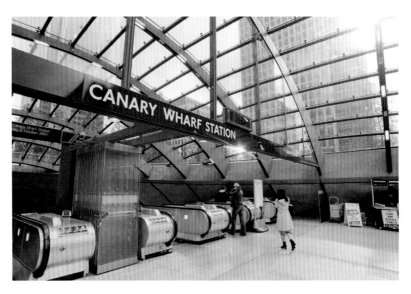

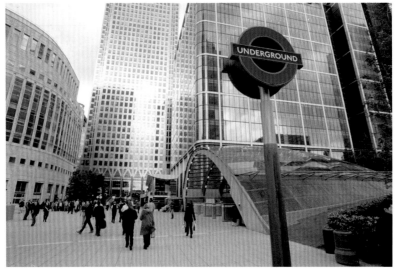

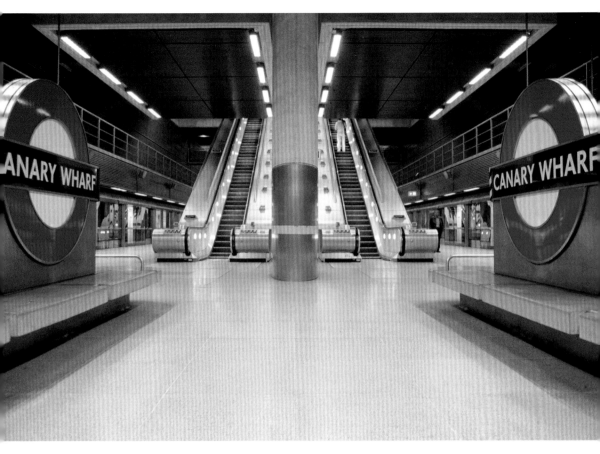

◀▲ Canary Wharf Underground Station.

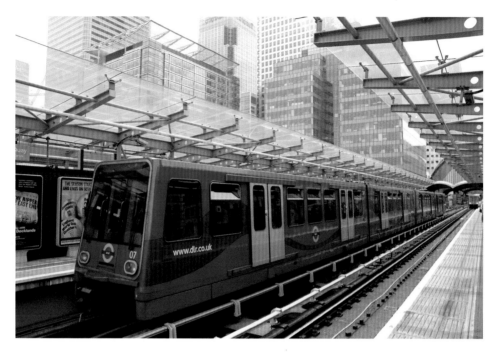

▲ **25 July 2008.** The Docklands Light Railway train at Canary Wharf.

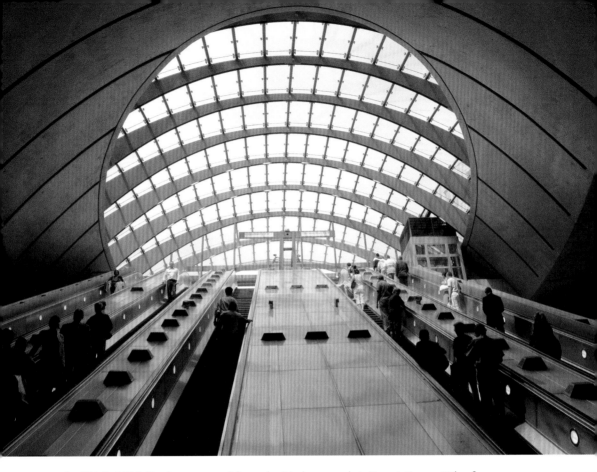

▲ **25 July 2008.** Escalators to and from the Underground station at Canary Wharf.

PARSON'S GREEN

As London has proven again and again, we will never be intimidated or defeated by terrorism.

Sadiq Khan, Mayor of London

At peak rush hour on 15 September 2017, a home-made bomb exploded on the District Line in what would be the fourth terrorist incident that year. The bomb – inside a shopping bag in a white bucket – failed to fully explode, but sent a 'fireball' through the rear of a carriage at Parson's Green Underground Station. No one was killed, but thirty people were injured.

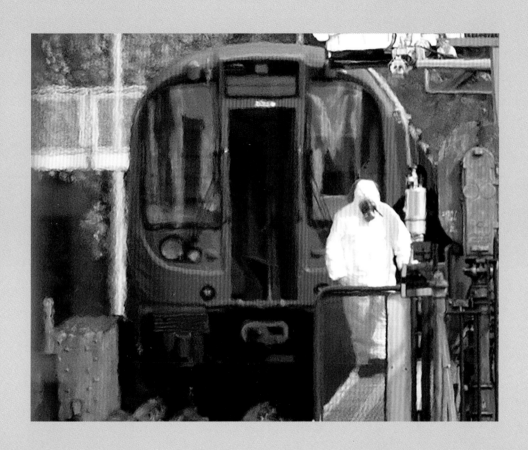

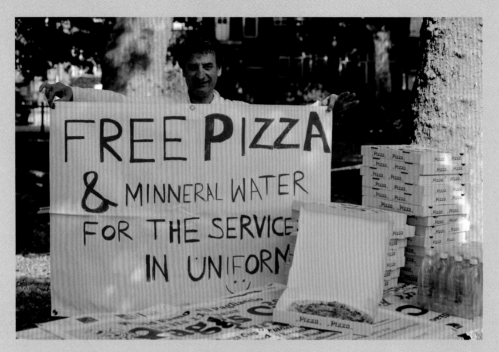

▲ A local pizza shop sets up a stall donating free pizza to members of the emergency services.

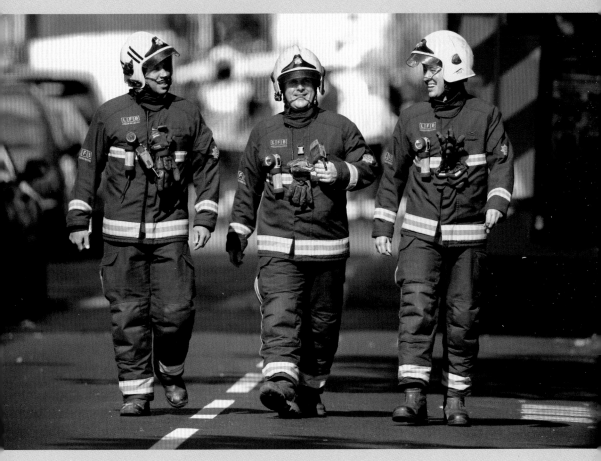

▲ Police and fire officers on the scene.

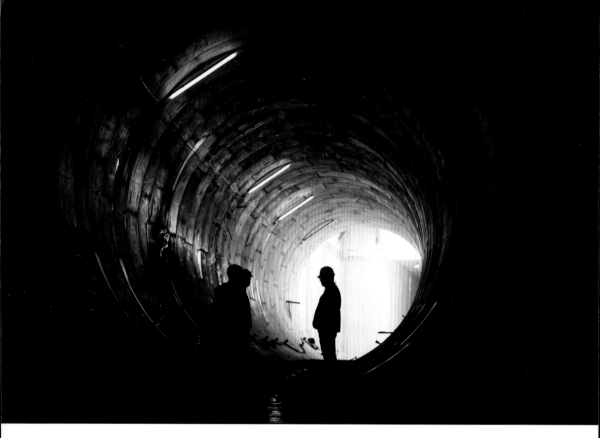

▲ **29 August 2013**. Workers inside one of the completed sections of the Crossrail tunnels at Woolwich.

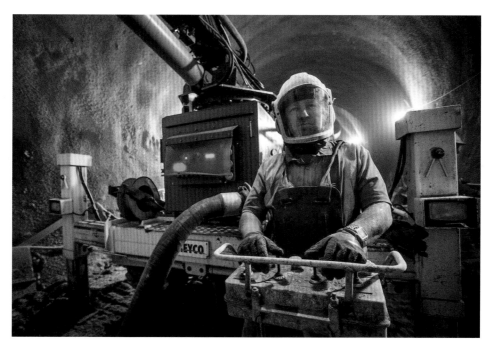

▲ **29 August 2013.** A worker operates a machine which sprays a cement compound onto the walls of the tunnels at Stepney Green site, on the Elizabeth Line route.

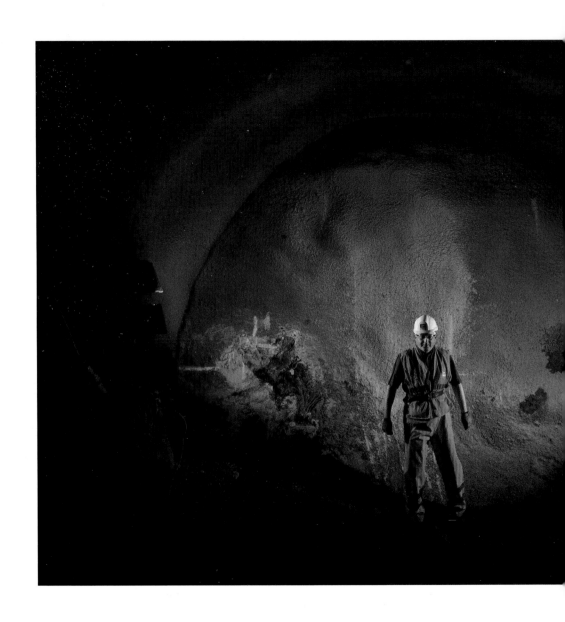

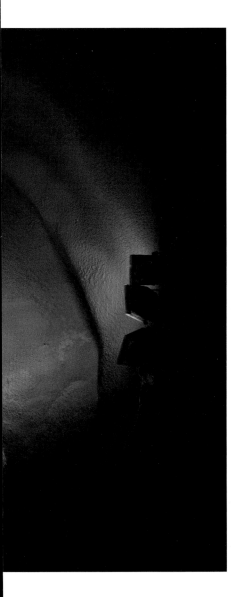

◄ **29 August 2013.** Another Crossrail tunnel, this time at Finsbury Circus. The project is the largest of its kind in Europe, with a plan for forty stations, and the full Elizabeth Line will open in 2019.

You may also enjoy …

978 0 7509 8785 1